ANTHONY EPES

PARIS
at Dawn

ANTHONY EPES

PARIS
at Dawn

CITIES AT DAWN PUBLISHING

Published by Cities at Dawn,
42-43 Lower Marsh,
London SE1 7RG,
England

First published in hardback by Cities at Dawn in 2013

ISBN Paris at Dawn: 978-0-9571081-1-0

British Library Cataloguing-in-Publication Data: A catalogue
record for this book is available from the British Library.

Design by Helen Crawford-White

Printed in Singapore by Imago

© Pictures copyright Anthony Epes 2013

1 2 3 4 5 6 7 8 9 10

www.anthonyepes.com
www.citiesatdawn.com

Dedicated to the lights of my life,

the centre of my world and the people

who make me laugh the most:

my children Theo and Tessie.

And remembering my father Jack Epes,

and Sula. I miss you both every day.

FOREWORD

John Bird, Founder of *The Big Issue*

I was made by two cities:
London, where I was born,
and Paris, where I escaped to.
The escape was not because of a romantic attachment to
a city loaded down with artists, thinkers and writers, and
endowed with the most magnificent settings. I left London
for Paris because the police in London wanted to arrest me
for criminal activity.

So I did not come with the usual baggage. But on
the very first day I was astonished at the intense beauty
of this city. Within a week I knew that Paris was much more
then a hiding-hole for me. It would be a place of rapid
transformation.

And so it proved. I fell in with revolutionaries in this
year, 1967, beautiful young men and women. I was twenty-
one. I was suddenly confronted with a beautiful city full of
what appeared to be beautiful people.

In London I had slept in the streets. In Paris I did not
need to. I found a place to work, selling newspapers to
tourists on the Champs-Élysées and around Concorde. I lived
up by Barbès in a kitchen, sleeping on a mattress. I had time
to walk everywhere. And there I discovered Paris at dawn.

I finished my selling at midnight and would head
towards the old market at Les Halles. There would always

be cafés open and people to talk to. Paris was very open if you were twenty-one and if, like me, you had thick black hair and might be a Beatles lookalike.

The air was alive with a kind of preparation for revolt. Students and young people seemed to mill around in large groups, often overseen by the Garde Mobile and the CRS, the riot control force of the police. But once you went to Les Halles and walked about through the night, as I did, you discovered a different, continuously-happening life of workers and walkers.

Paris of the day seemed chaotic and obsessed with politics. But Paris at dawn was the most magical time to be living. Paris at dawn was where you might imagine yourself living in history. With the city quiet and hardly stirring, standing in the Place de la Concorde or in Place du Tertre in Montmartre was the nearest I found to feeling complete contentment with life.

I did sleep out but not because I had to. Now away from the threats of London, I could relax and drink in the beauty of this great city. And there I could sit and watch as the dawn came up and the city shrugged itself awake; slowly, carefully, like an old man might wake.

Anthony Epes' photographs capture that eerie silence that often you discover at dawn in Paris. How can a picture capture silence? Look and see. Many are places hidden, old rail tracks, quiet corners that I never saw; each of the photographs adds to your knowledge and appreciation of this great, creative city. This city where, with camera in hand, Anthony has added a new dimension to our understanding of it.

If I were to pick one picture to capture the essence of Paris at dawn, it would be his picture of the Canal Saint-Martin. The reflections of the tall apartments caught on the canal's surface; a complex series of lines splashed on the face of the water. It causes me to remember the airs and atmosphere of the dawn, and not just the appearance at that time and hour. It increases and adds to my understanding of what Paris is. It is a new dimension.

Paris at Dawn is a series of reflections of a city that often gets looked at differently. These photographs add to that difference. Anthony has caught the city almost by surprise, unconscious. And for that we must thank him for this new way of seeing the great beauty of the city of Paris.

10% of the net profits from this book and print sales for this project will be donated to The Big Issue.

INTRODUCTION
Anthony Epes

Over a period of two years, I have wandered the streets of Paris from the dark hours of night until the sun breaks through and lights the city with a mesmerising dawn. It is a time rarely seen by its inhabitants, particularly in summer, and yet it is one of the most beautiful times of the day.

In my early morning wanderings, the streets are mostly empty, except for the few people who are toiling at this hour, preparing the city for the day ahead when, with a great rush, the streets are filled with people. Sometimes I encounter revellers reluctant to accept that the night is over. But mainly I am alone.

Paris is the second city I've photographed at dawn. My expectations of Paris after completing my *London at Dawn* book were pretty much the same, but I found them to be vastly different cities through the lens and at street level. London is a conglomeration of centuries of architecture, whereas Paris has a uniformity. Its architecture is a constant. The city has a purity of form and grace, and that is where its beauty lies. The enchantment and mystery of Paris was well-planned and can be most appreciated at dawn when the streets are bare and exposed.

I wanted to present a vision of the city that Parisians and those who love this city will recognise, but at a time that is mostly unseen by people. I didn't want to present a chocolate-box, sentimental vision of the city, nor one that ignores its beauty. It is a city that is extraordinary, but at the same time gritty and challenging. It entices, but it can also alienate. I find it both seductive and frequently impenetrable.

My desire for this book is for people who know the city well, and for you the reader, to say *'ah, this is my Paris',* but I also want you to find something new. Perhaps in the small details that I notice, a street that you have never seen that piques your curiosity, a person emerging from the night or how the light hits your favourite building at sunrise.

I believe a great happiness in this world is to be always finding something new and refreshing in the world around us. If we notice the beauty in our day-to-day surroundings, it leads to a richer daily life. It is with these sentiments, these thoughts, that I give you *Paris at Dawn*.

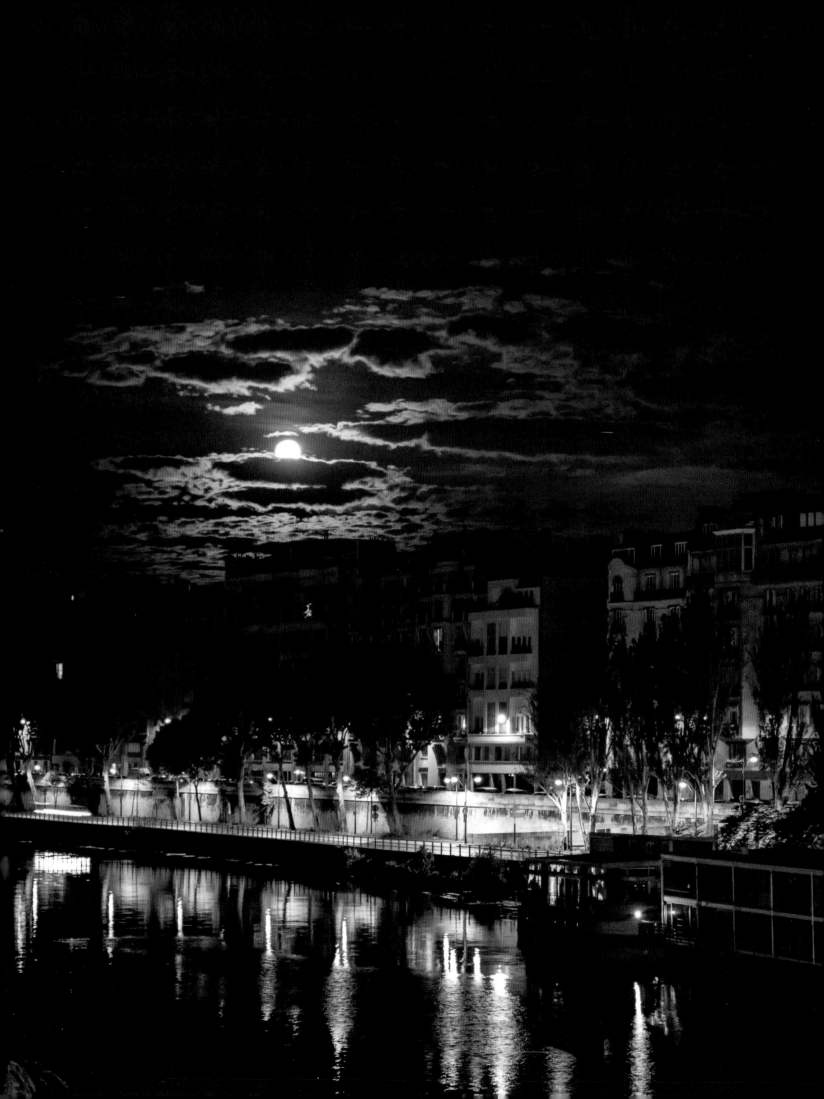

Moonset, Pont de Grenelle

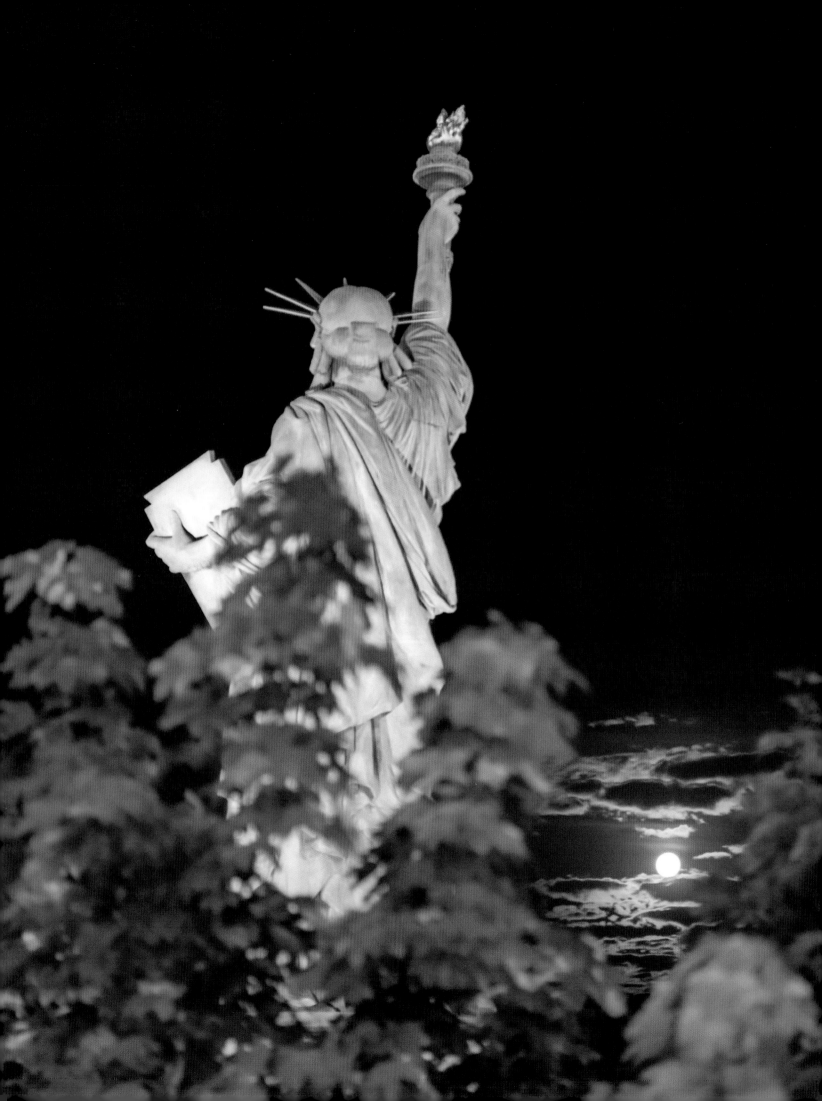

Réplique de la Statue de la Liberté from Pont de Grenelle

Rue de la Convention

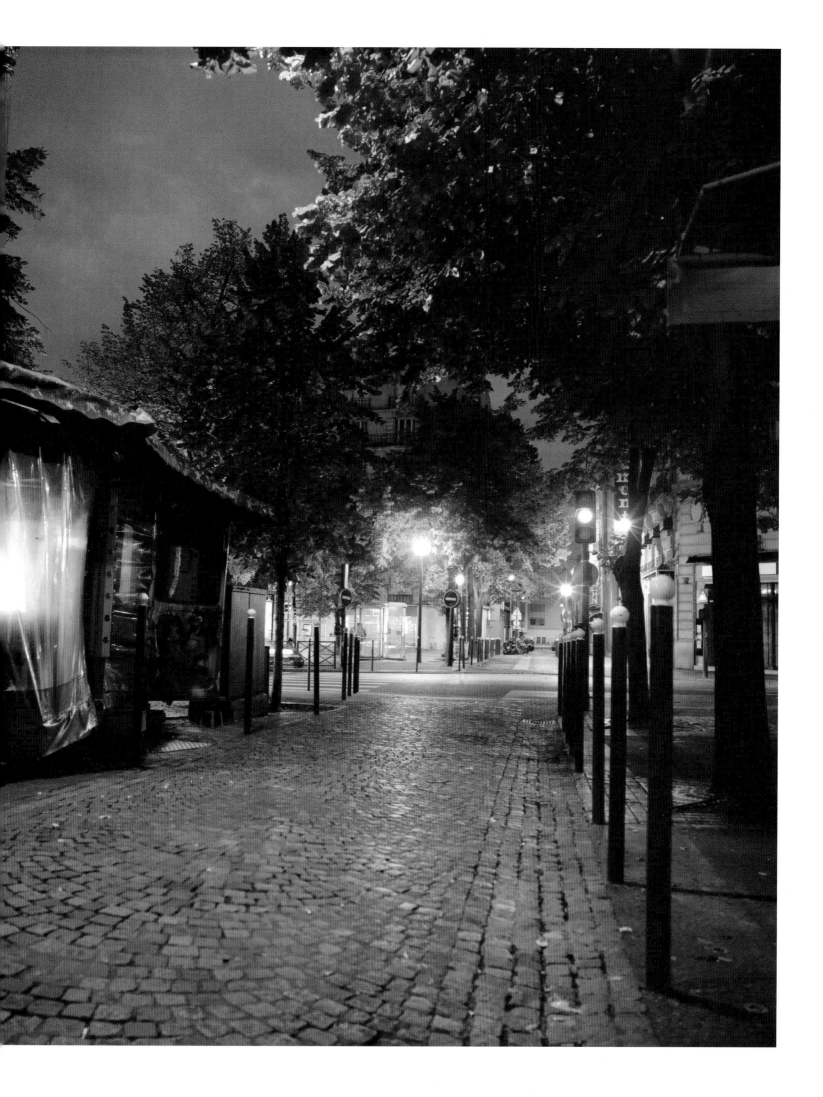

Pont de Bir-Hakeim

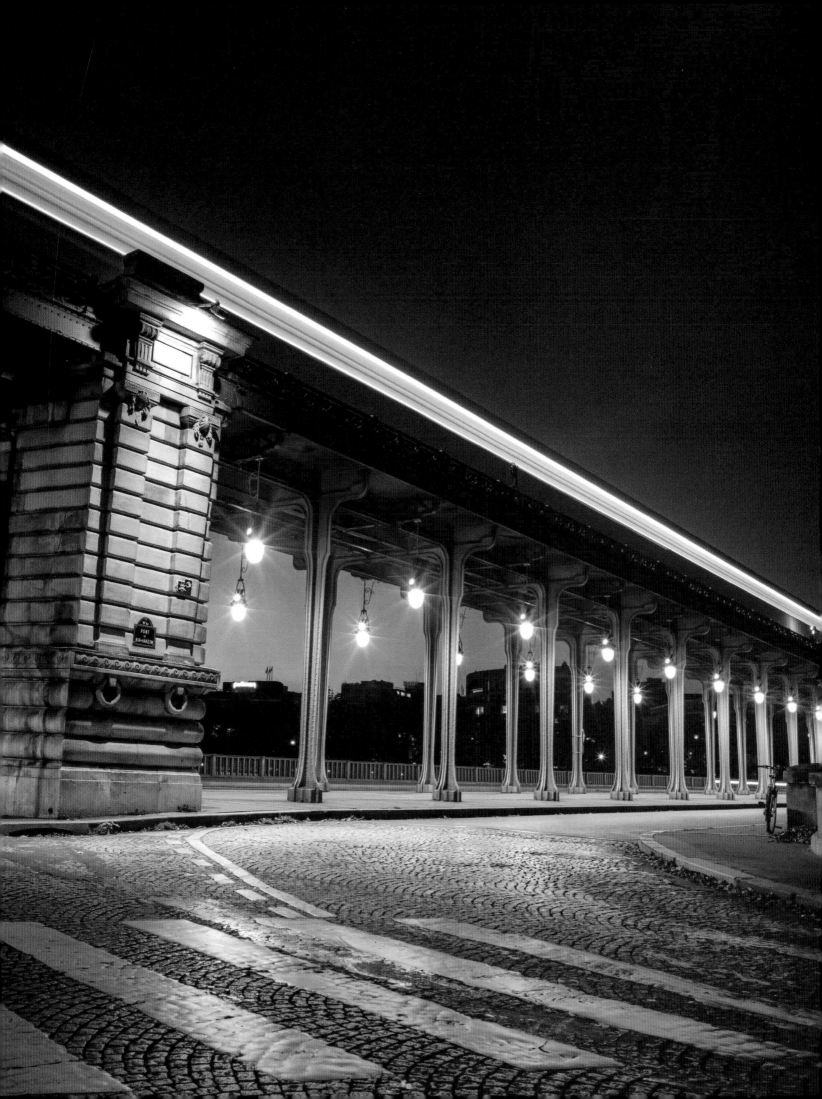

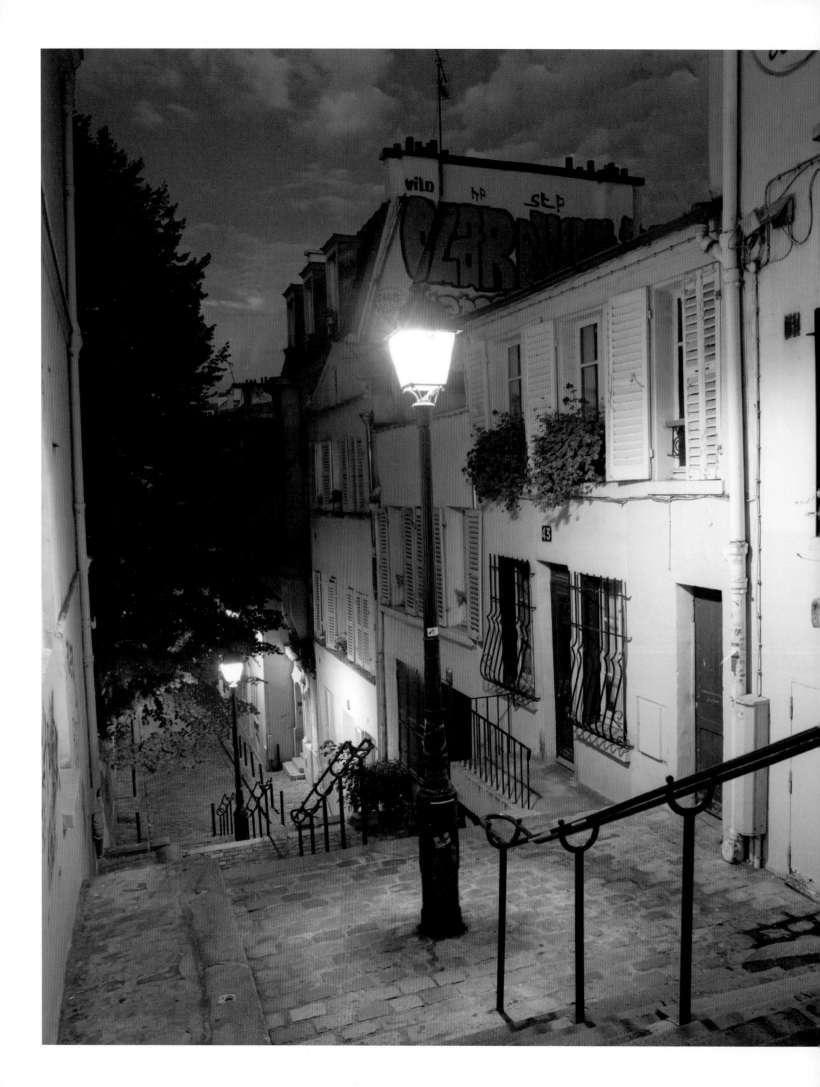

Steps at Rue André Antoine

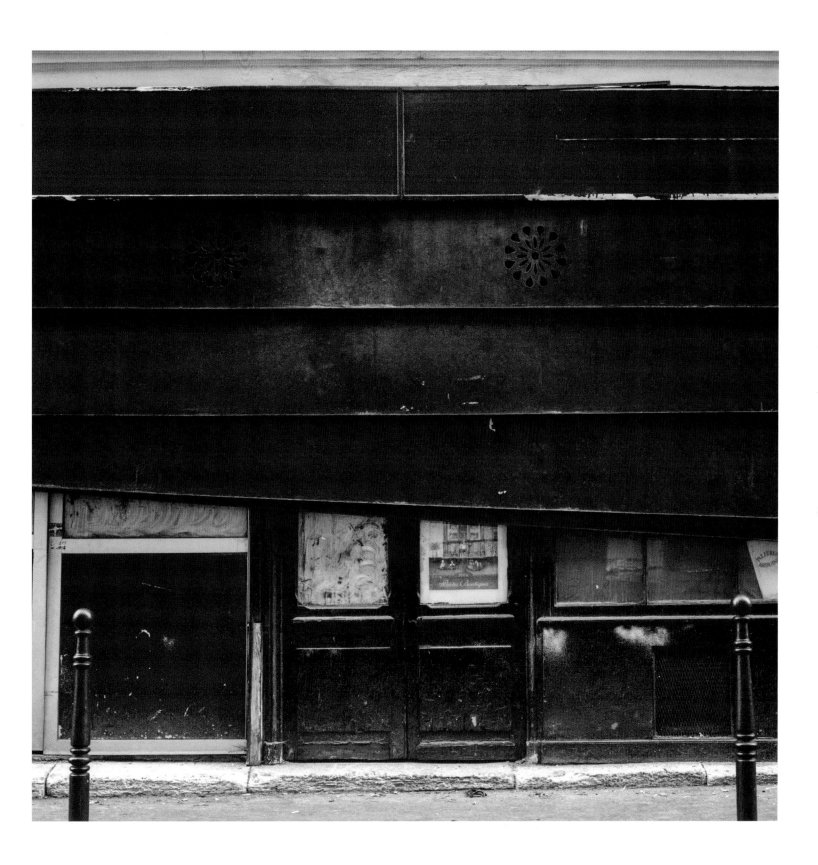

left. Café, Montmartre

above. Shuttered shop

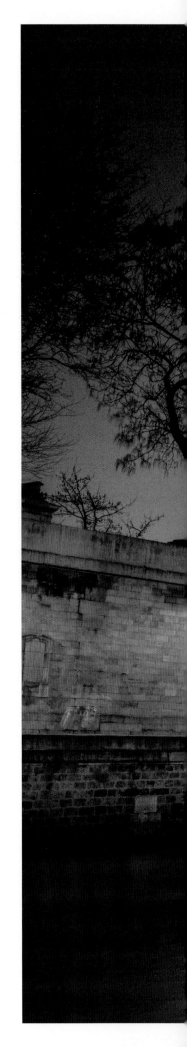

Cathédrale de Notre-Dame de Paris, from the Seine

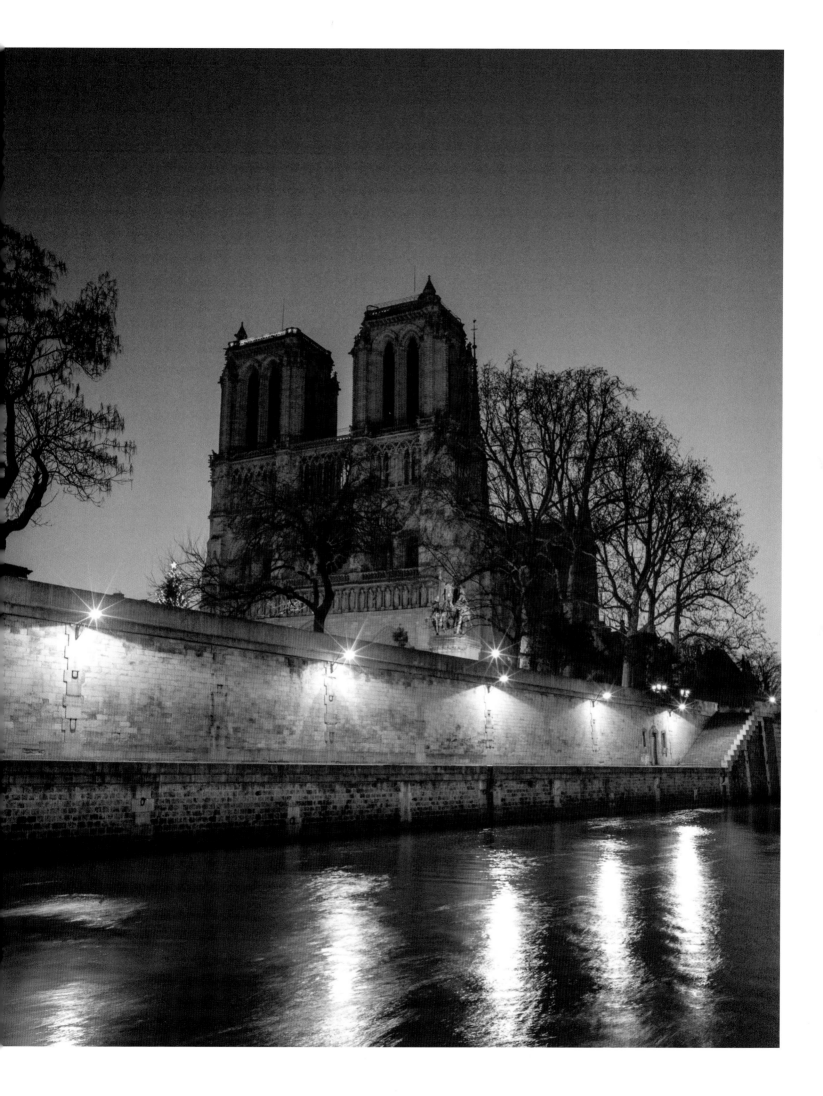

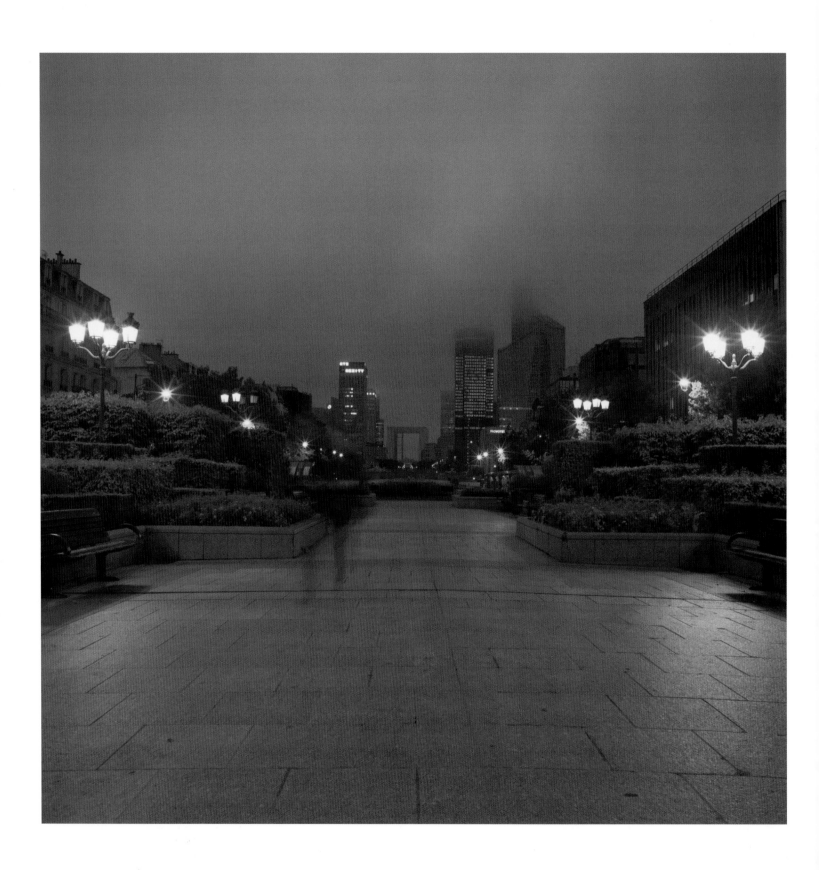

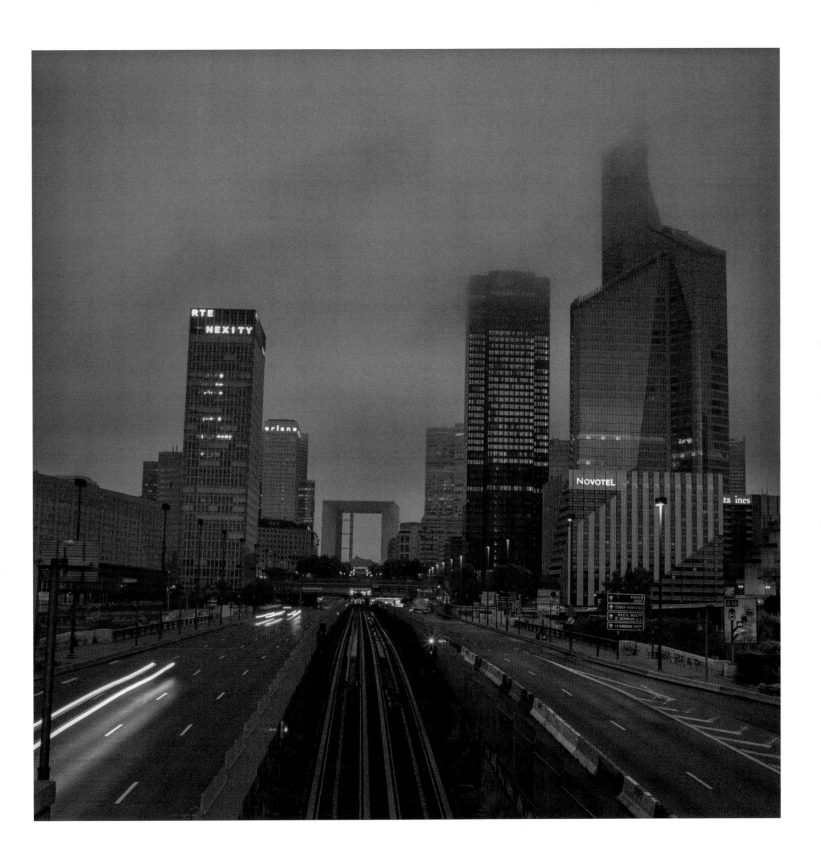

left. Esplanade du Général de Gaulle, La Défense
above. Rue la La Défense in fog

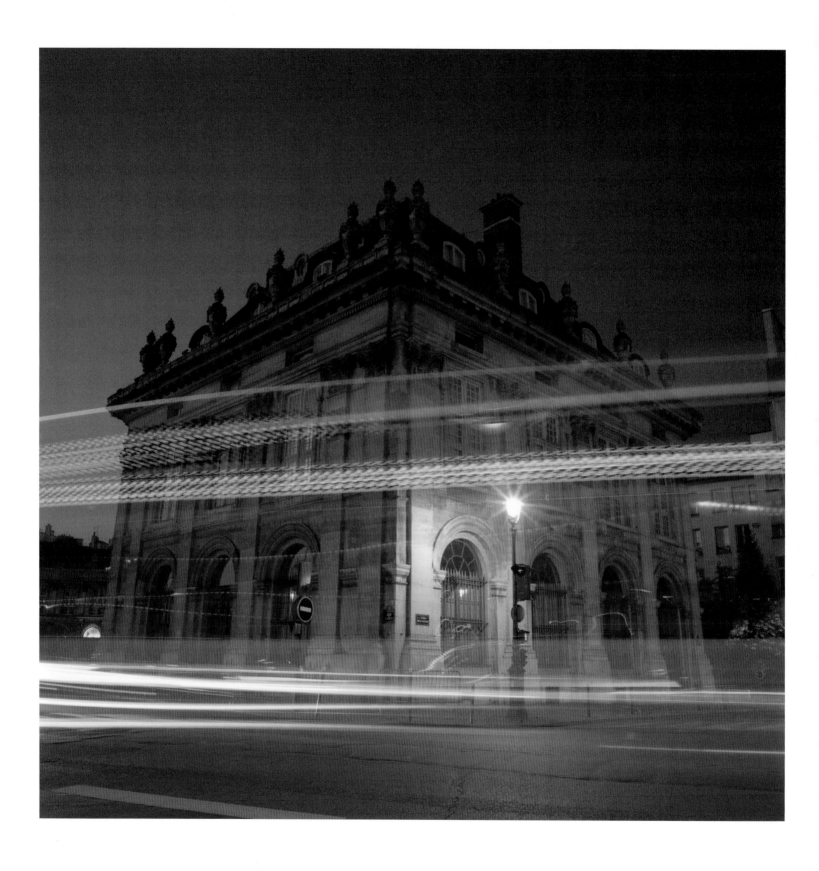

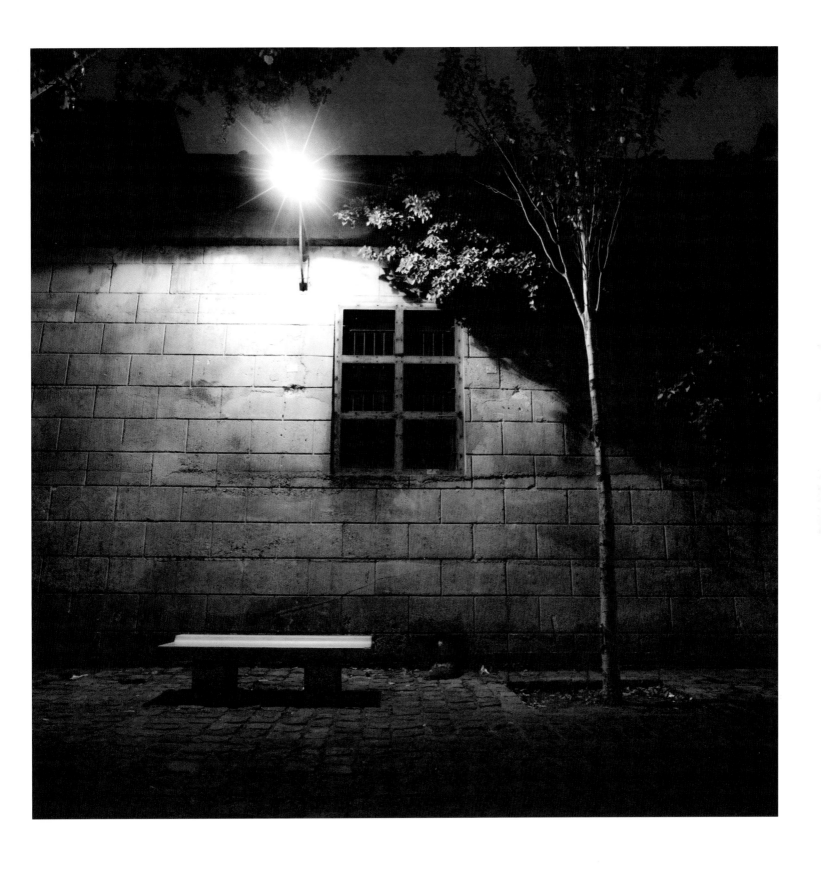

left. Quai de Conti
above. Stone bench and lamp by the Seine

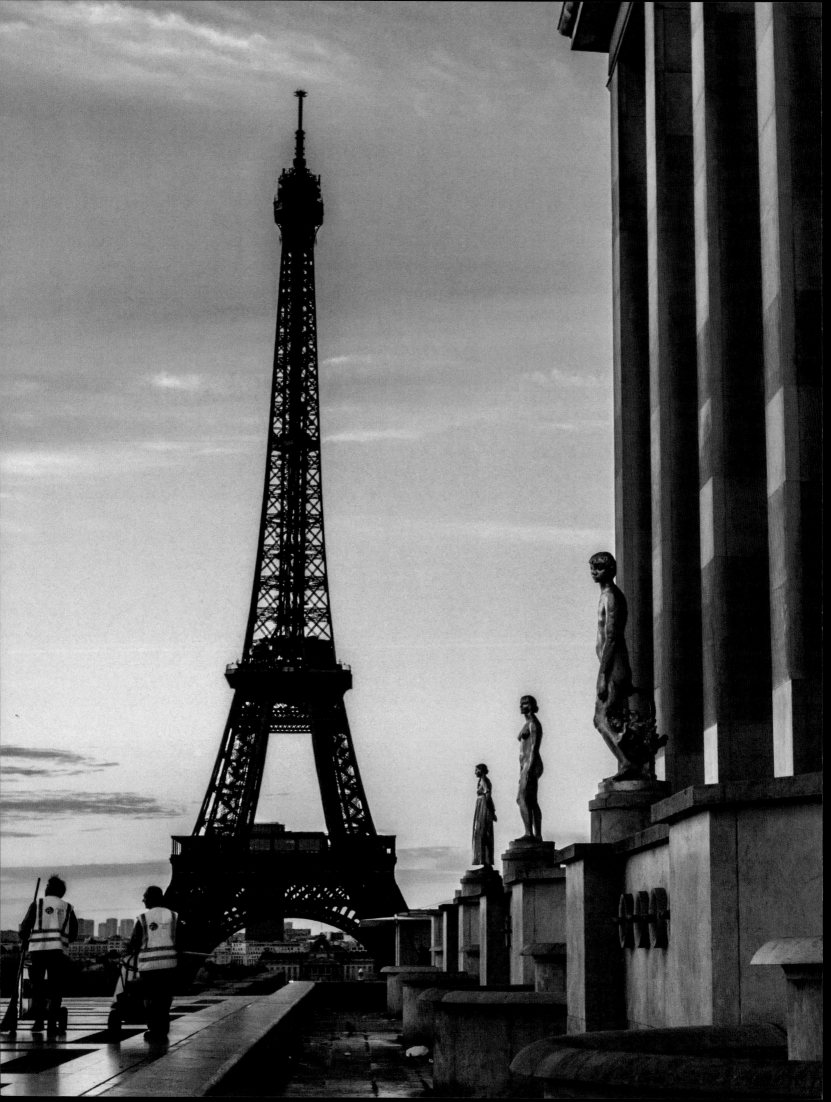

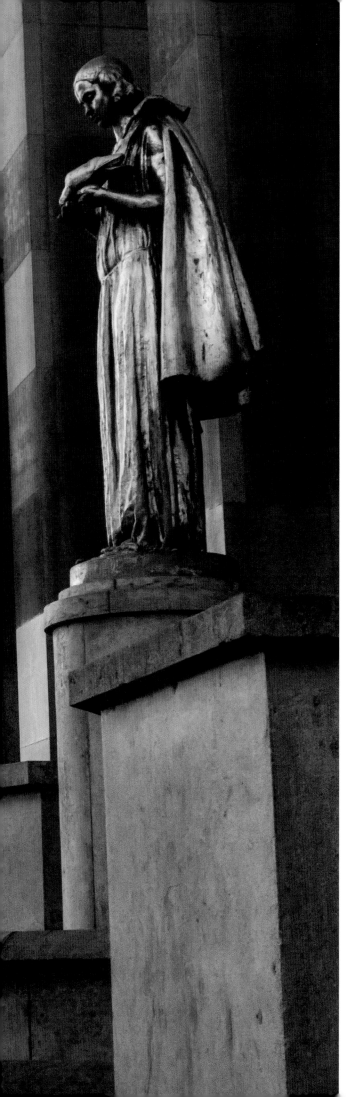

left. Workers on the Trocadéro

over. Eiffel Tower from the Trocadéro

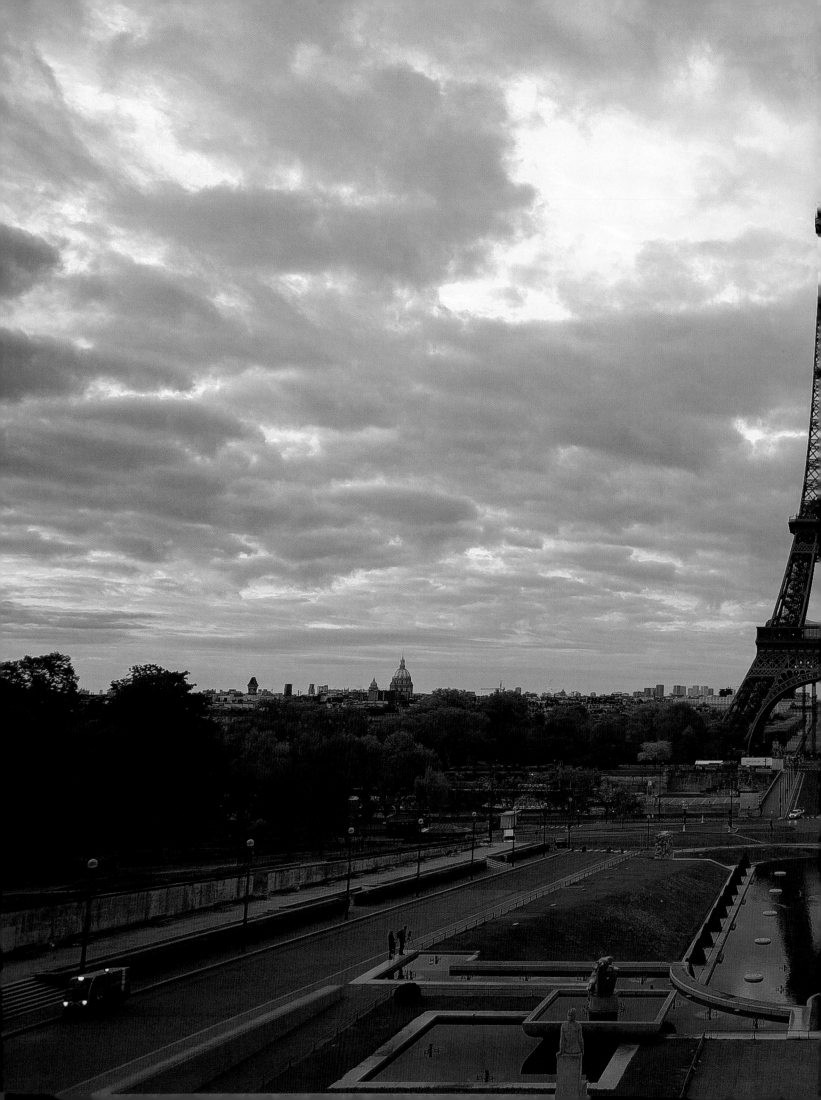

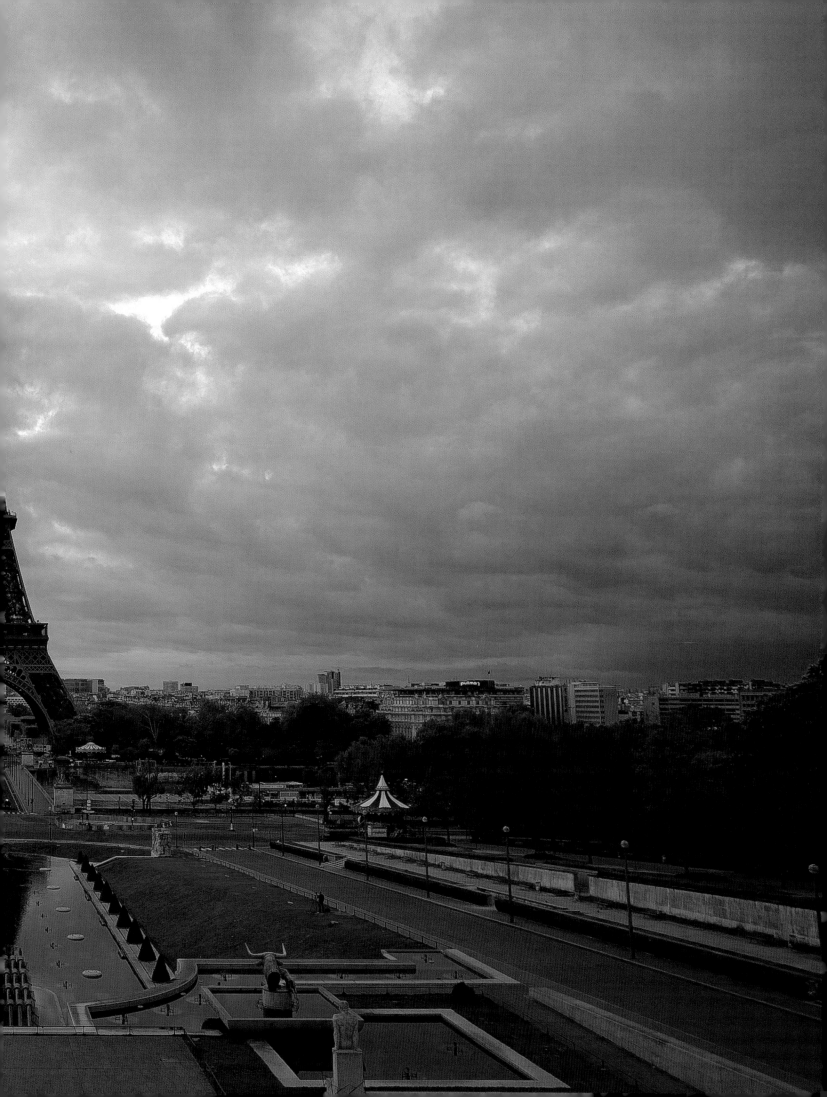

Montmartre

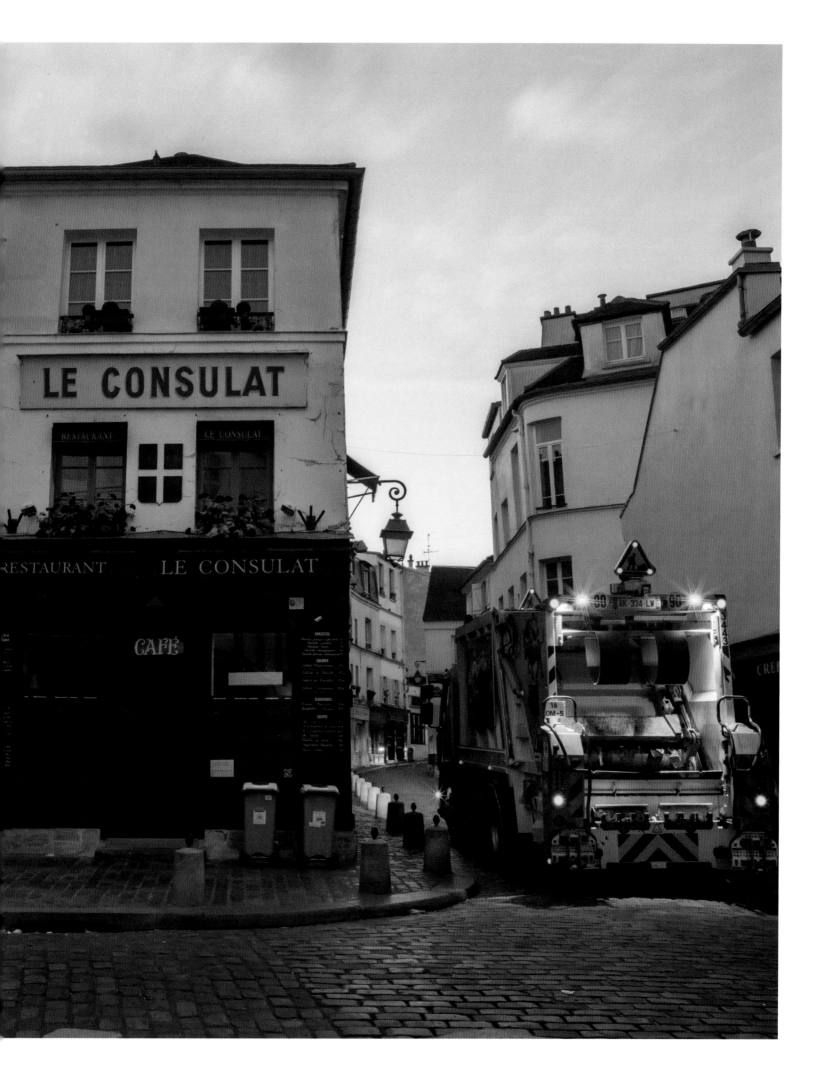

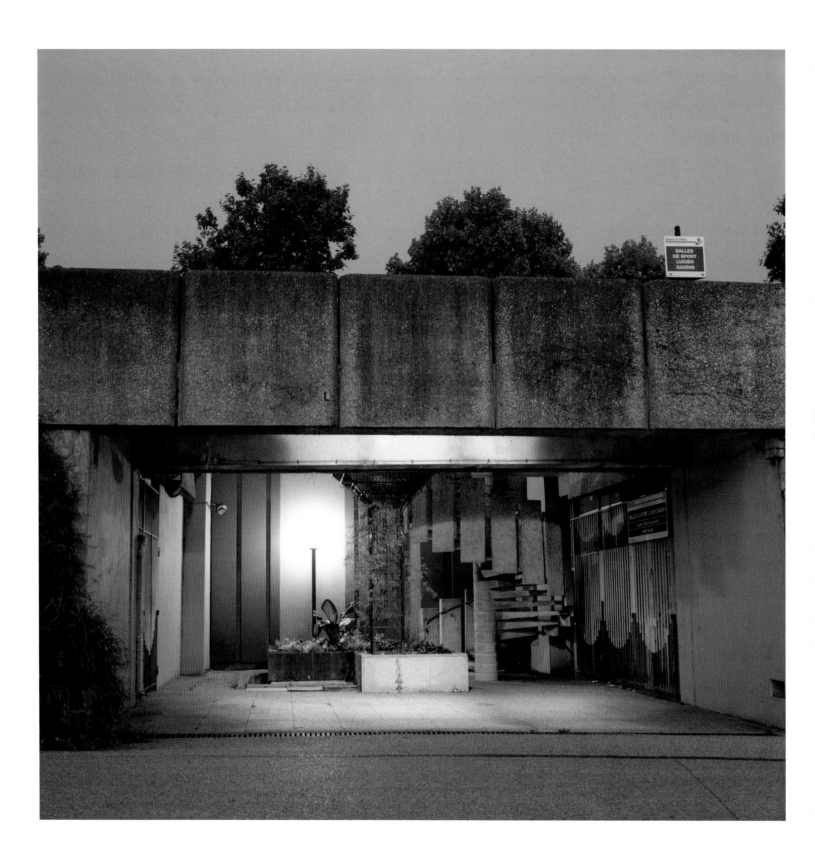

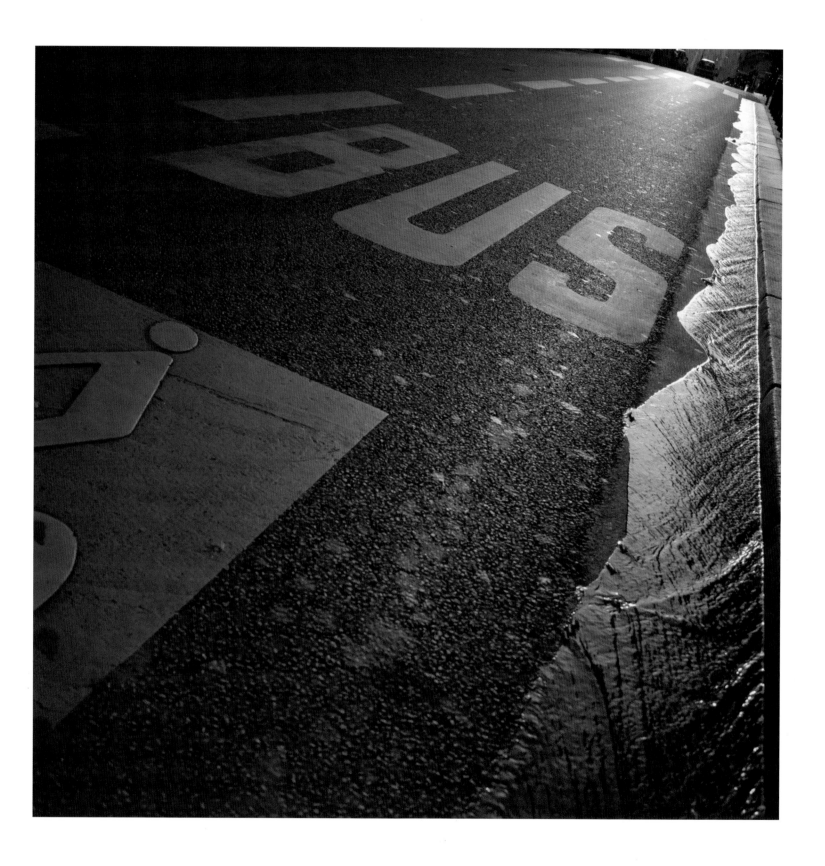

left. Salles de Sport Lucien-Gaudin

above. Street cleaning

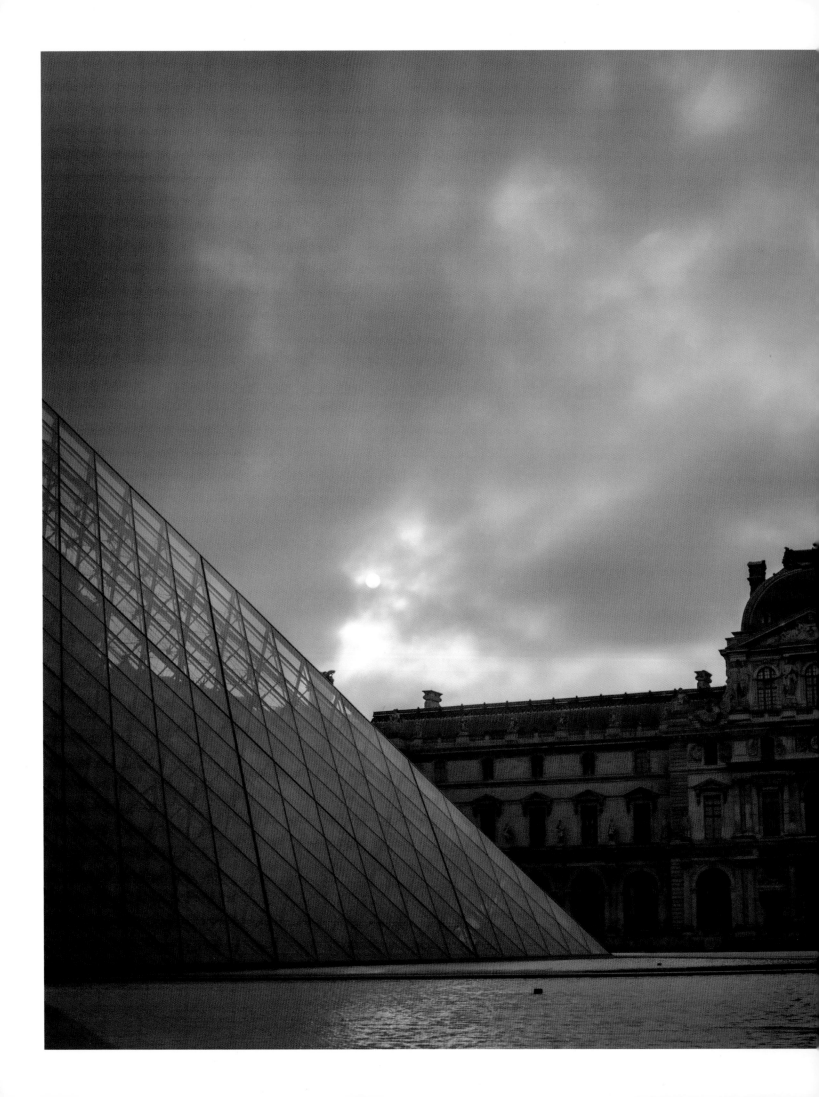

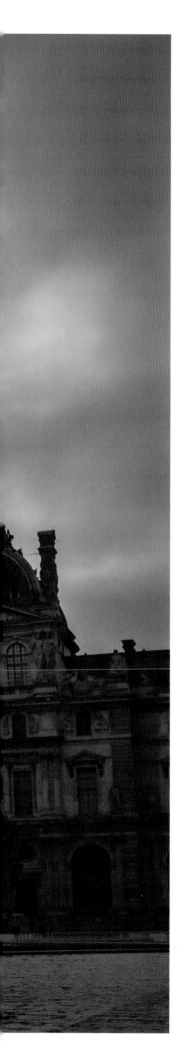

above. Musée du Louvre

Factory from rue Victor Hugo

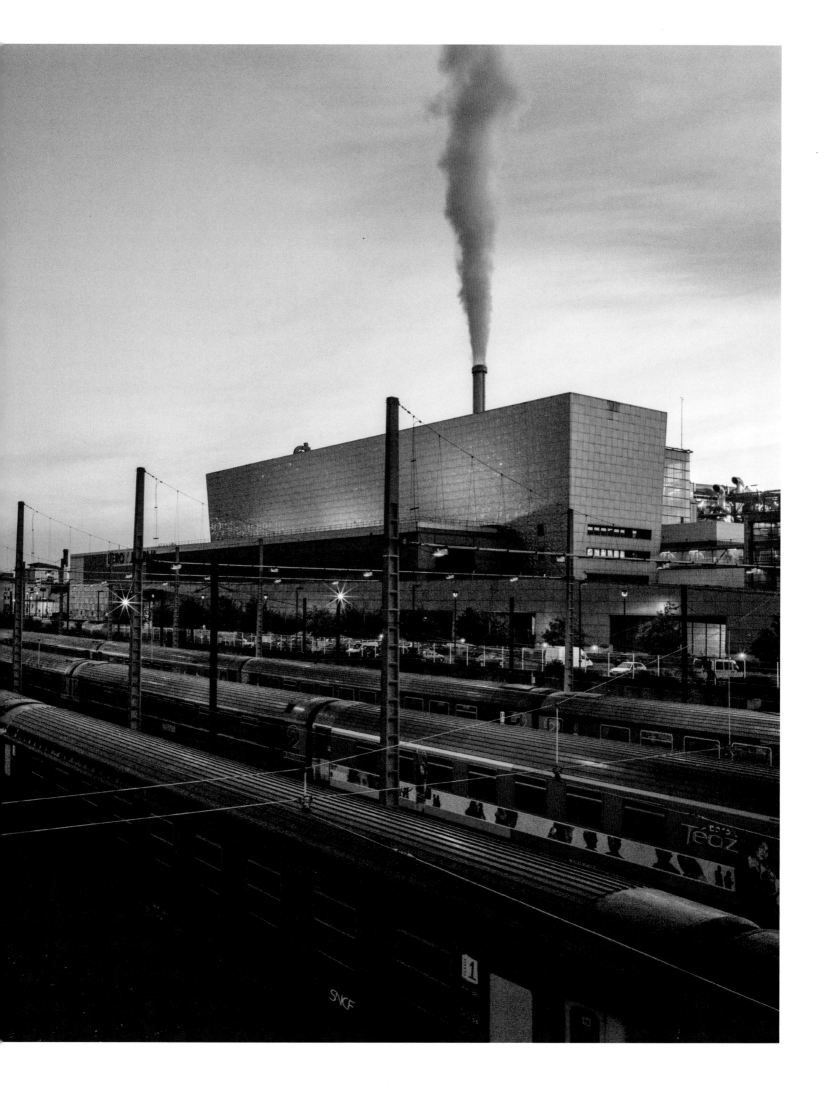

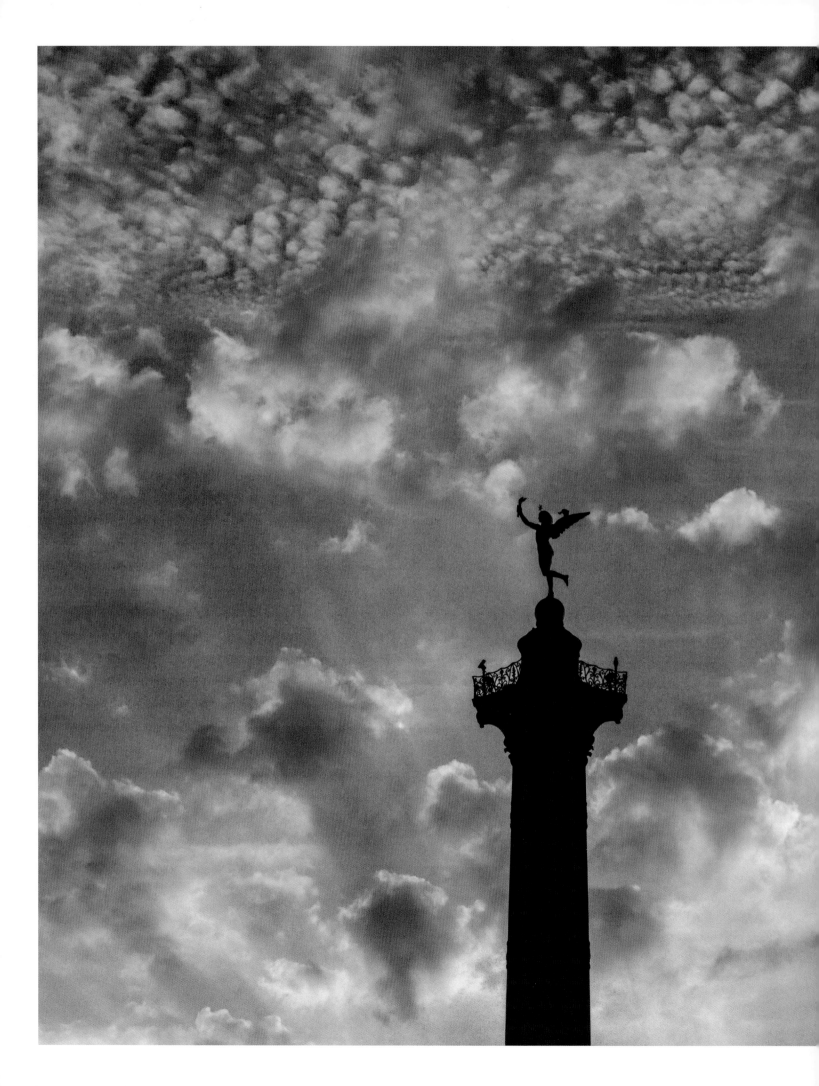

Colonne de Juillet, Place de la Bastille

right. La Géode, Parc de la Villette

over. Blossom at dawn

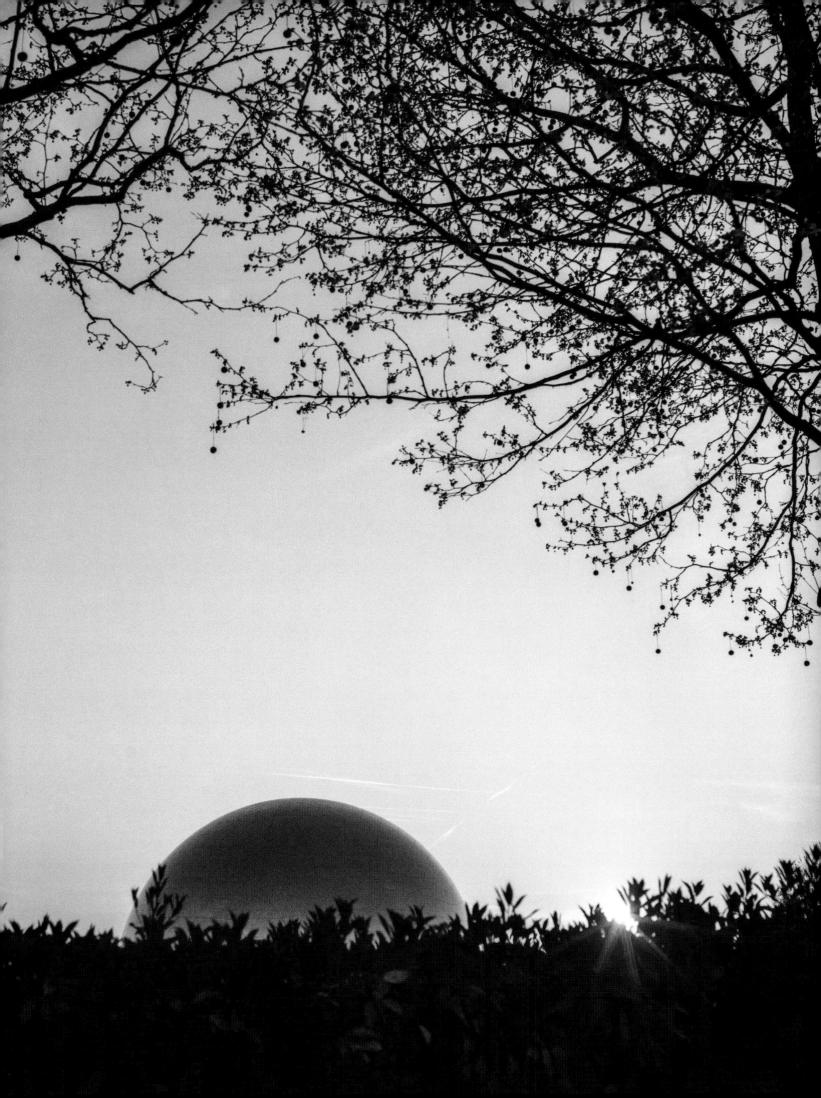

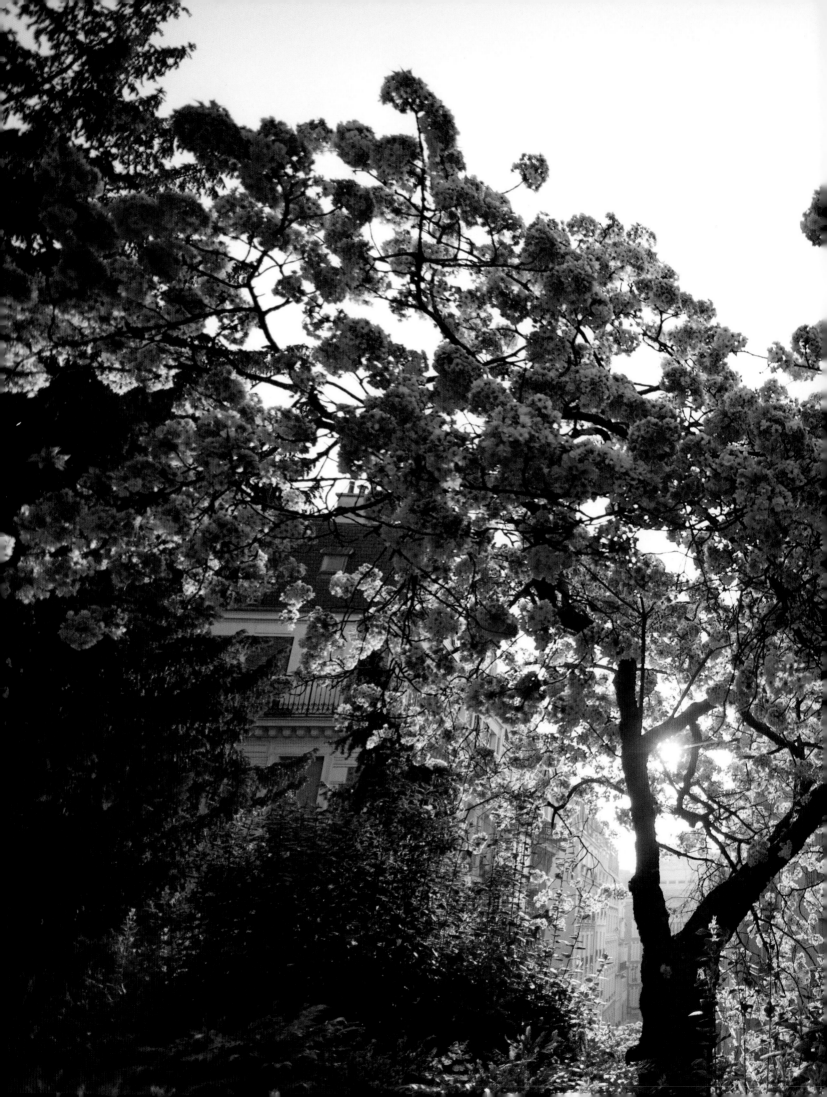

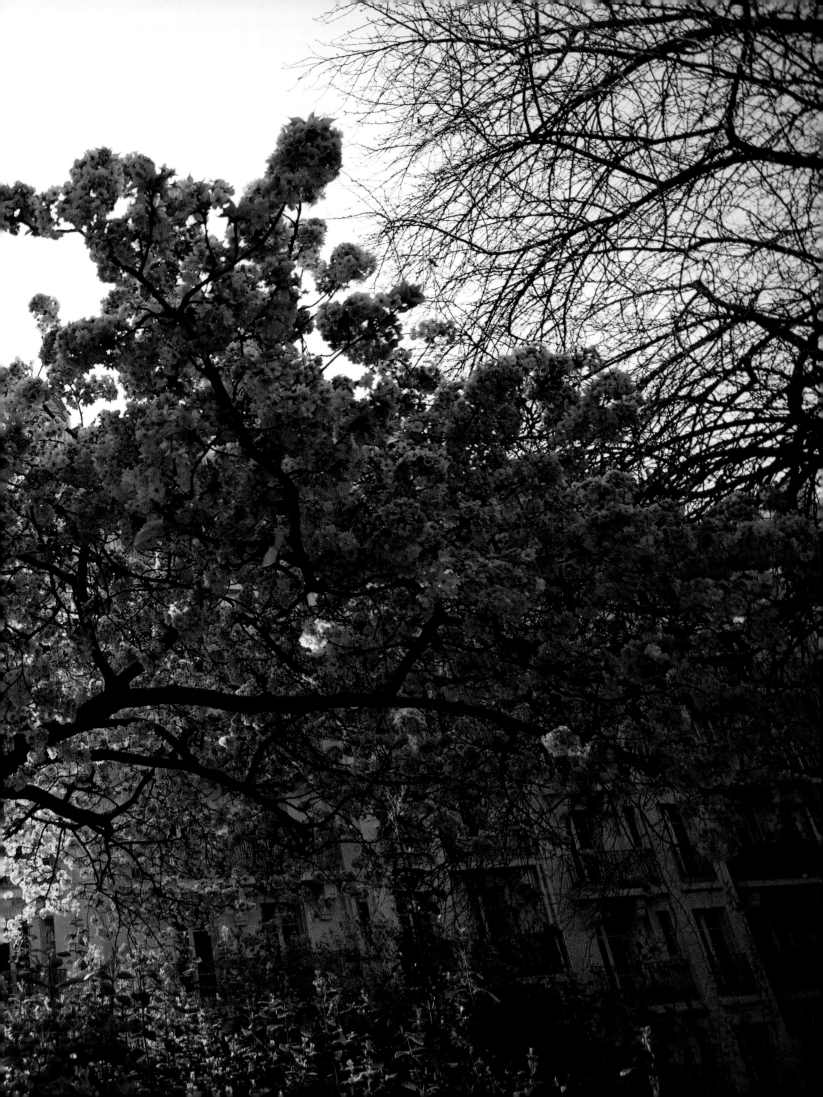

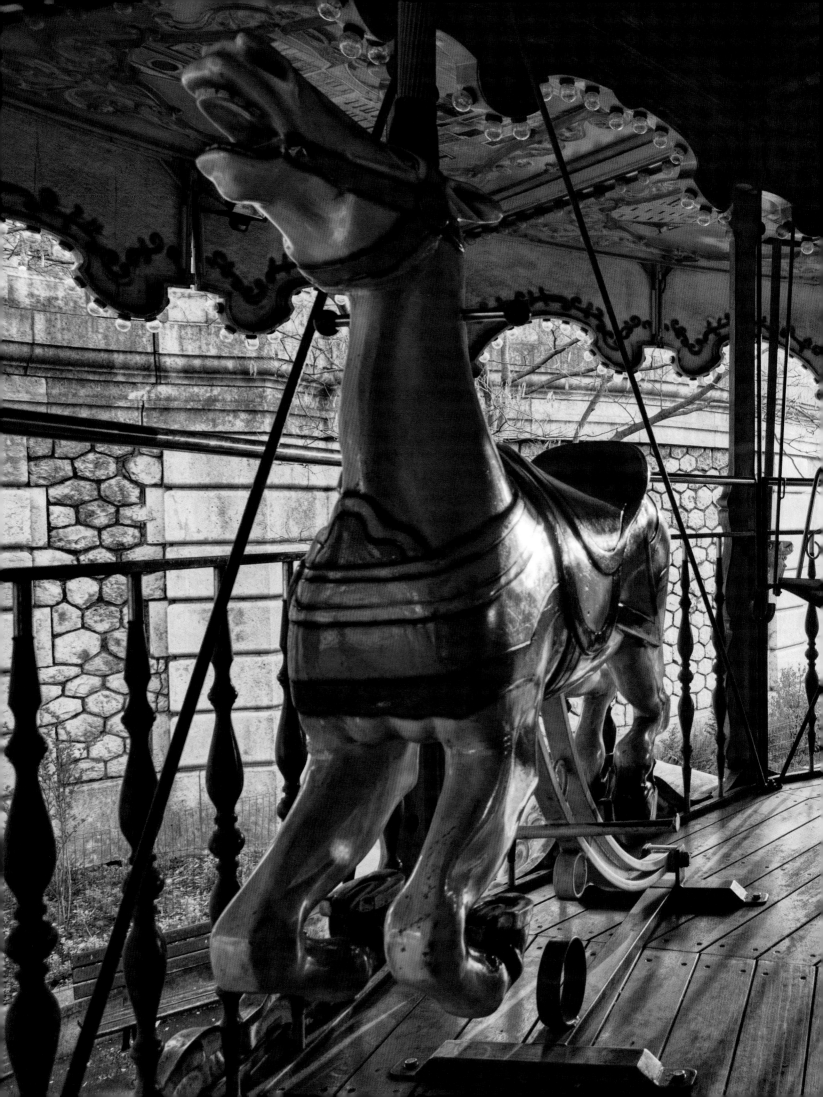

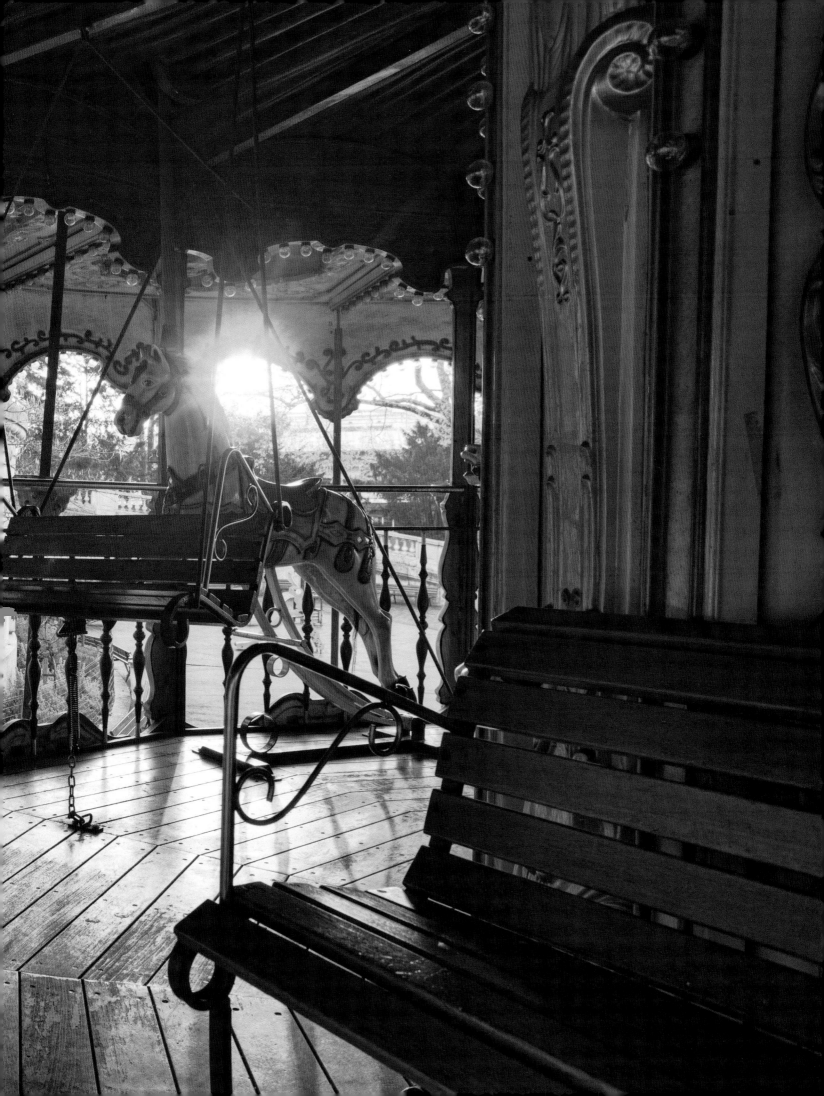

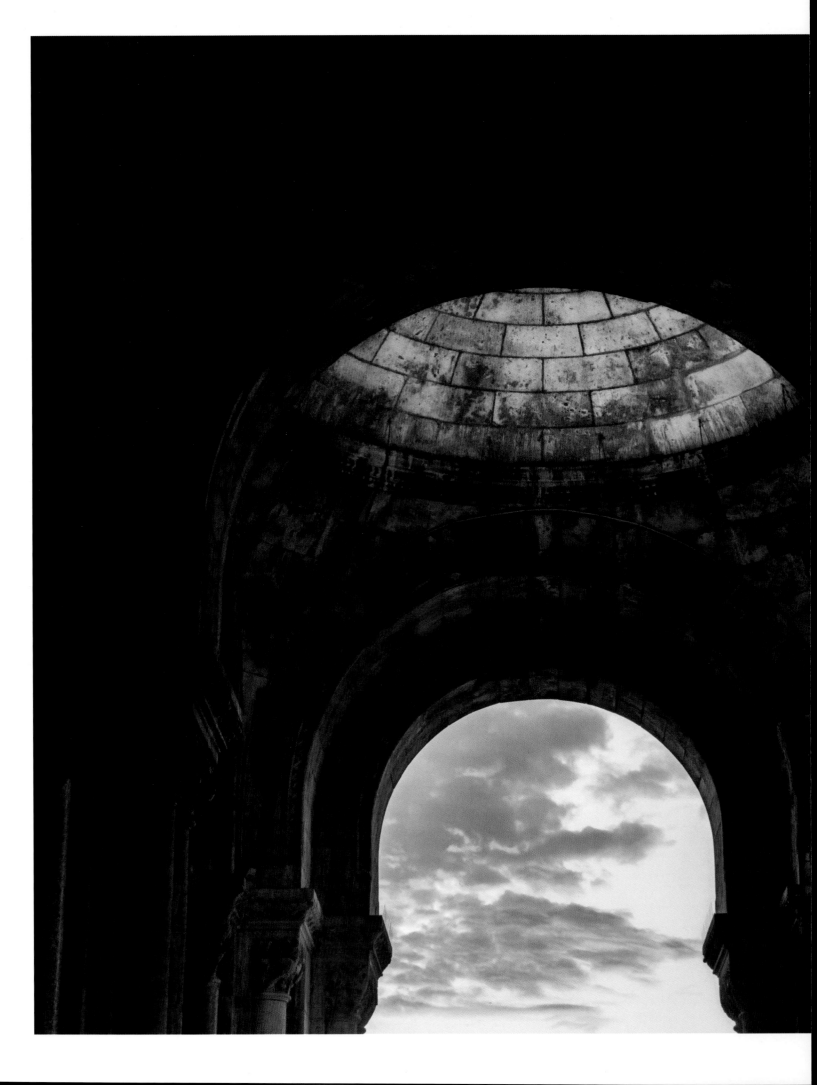

previous spread. Carousel at daybreak

left. Basilique du Sacré-Cœur

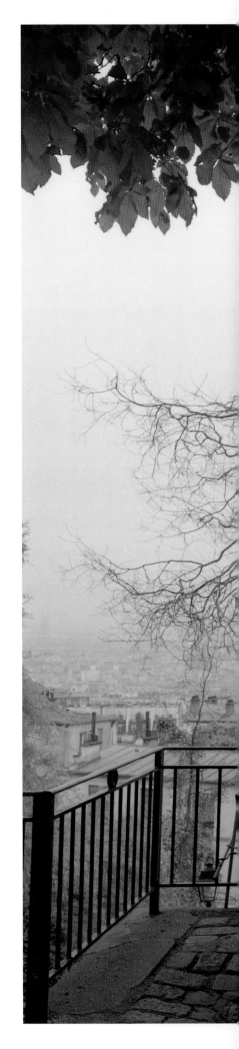

right. Feline eyes on Montmartre

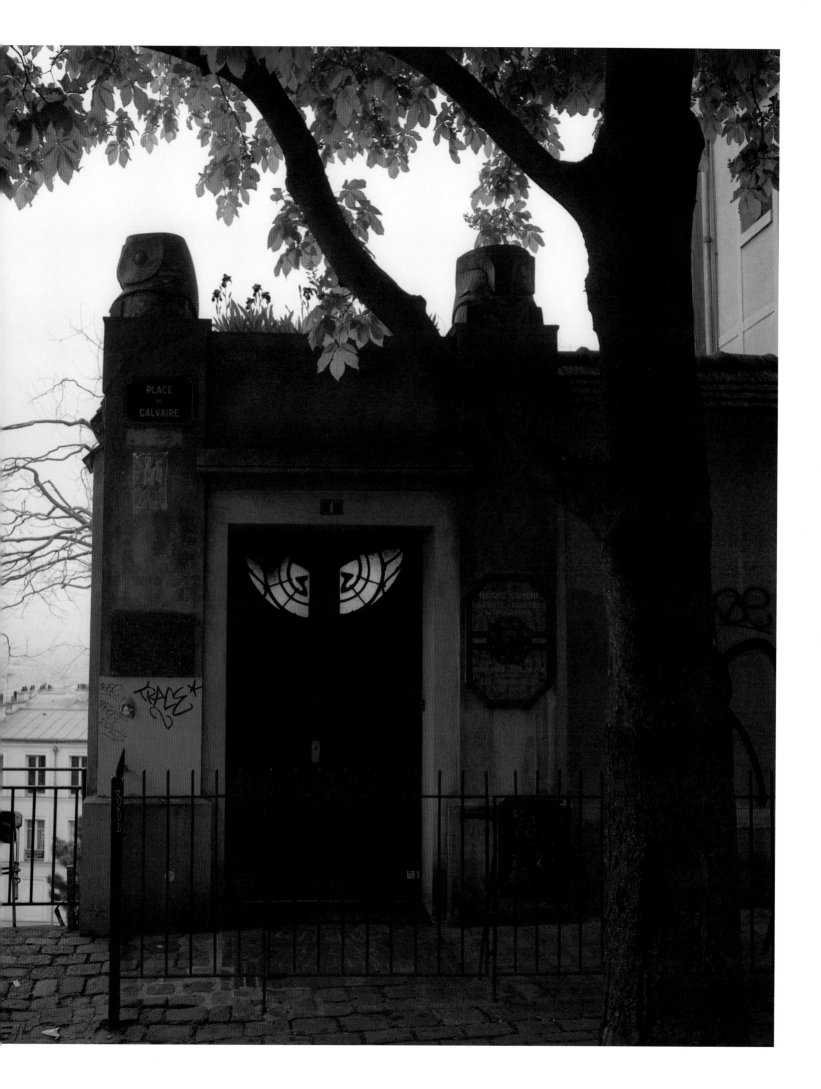

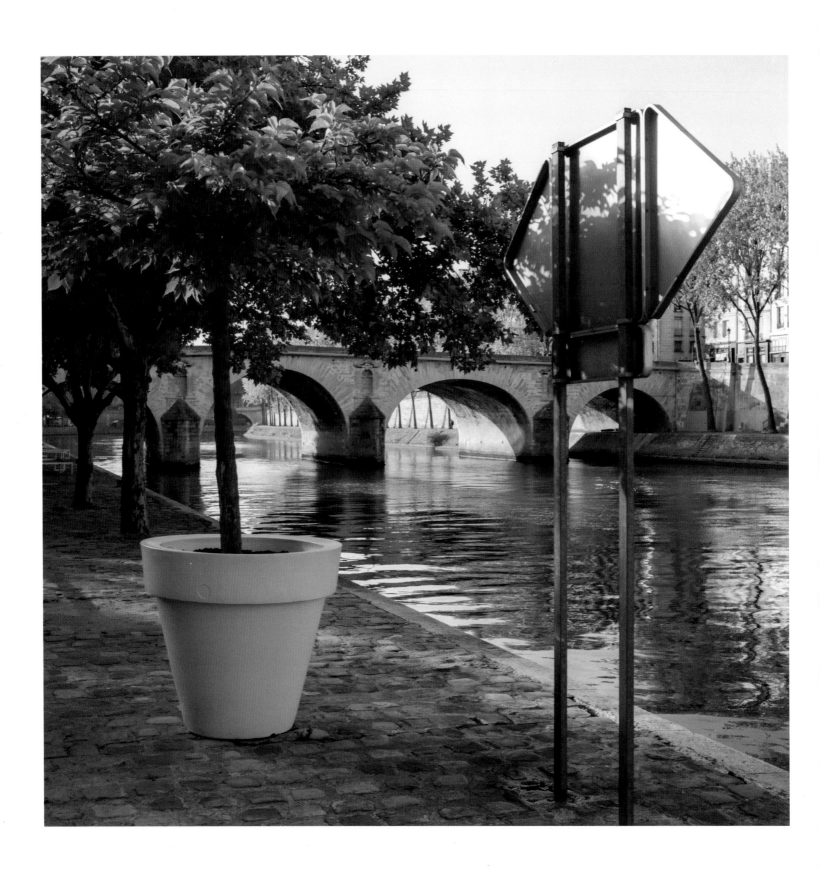

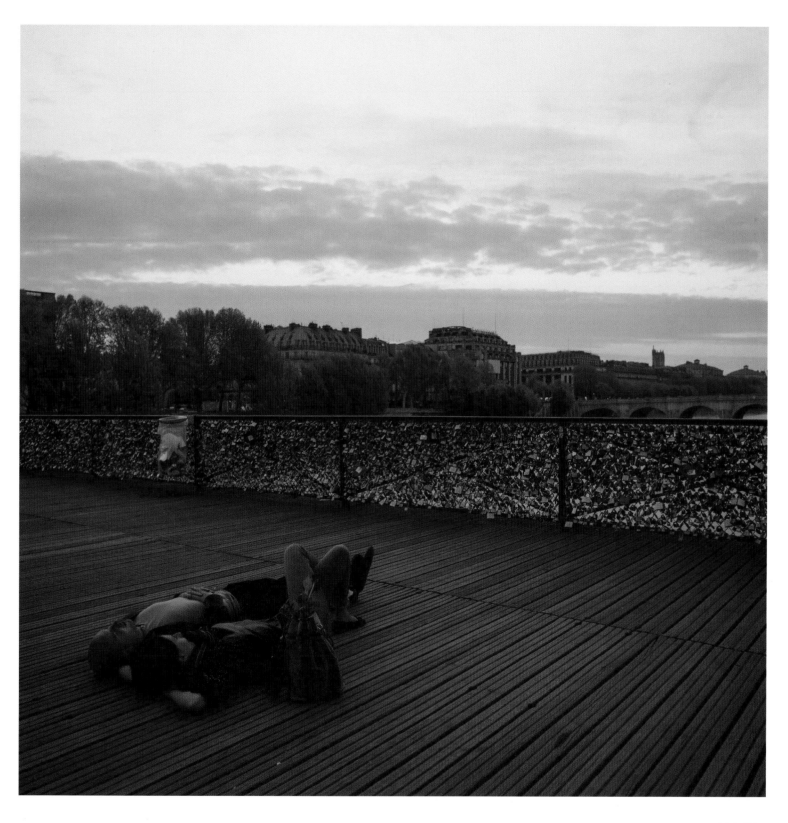

left. La Seine
above. Cloud-watching, Pont des Arts

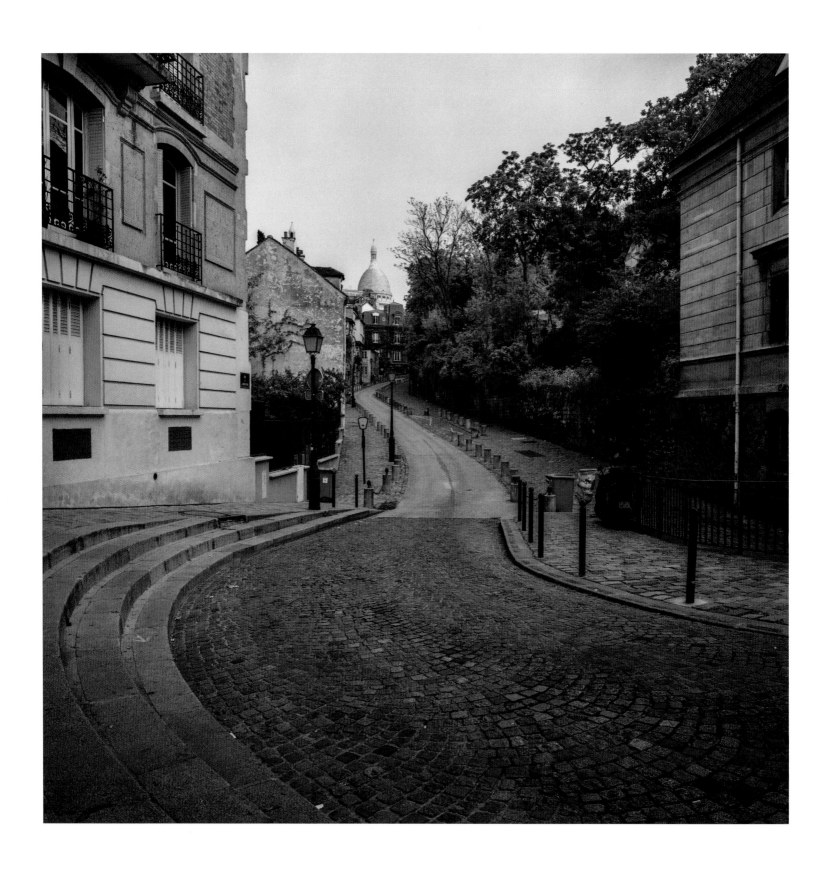

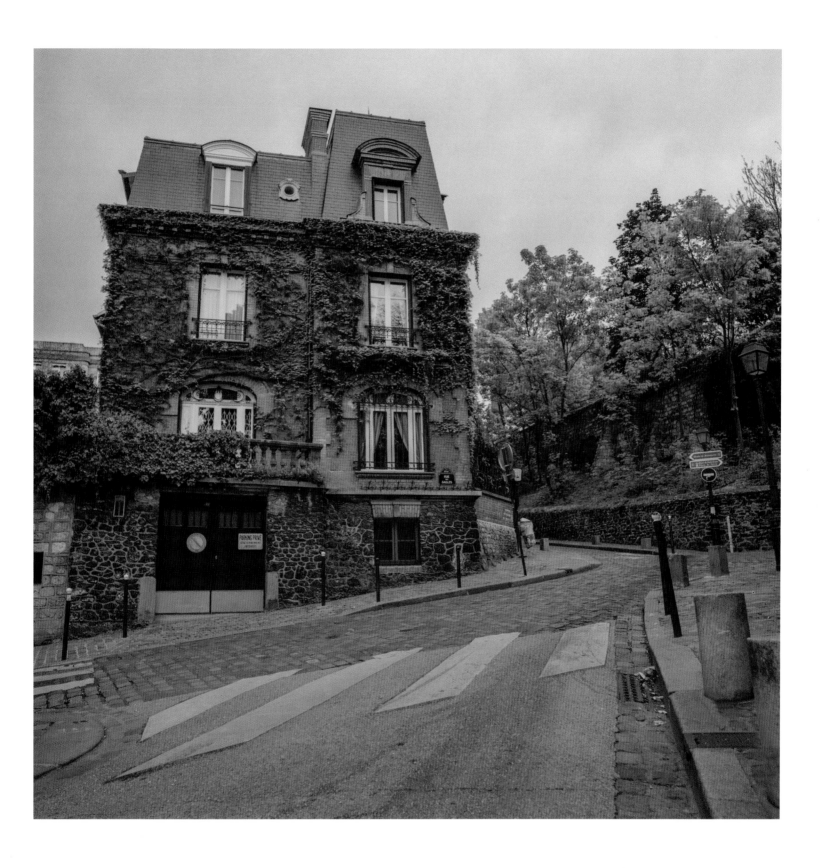

left. Rue de l'Abreuvoir
above. Rue de l'Abreuvoir at rue des Saules

Sunrise over the Seine

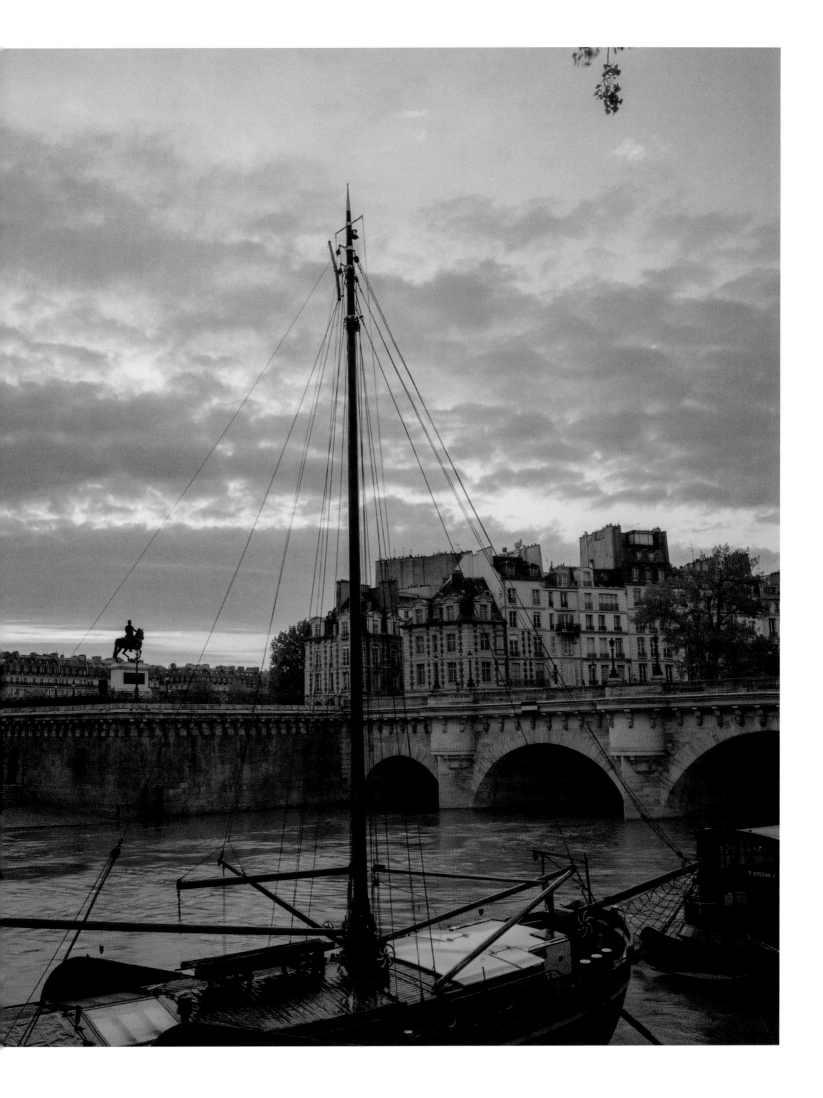

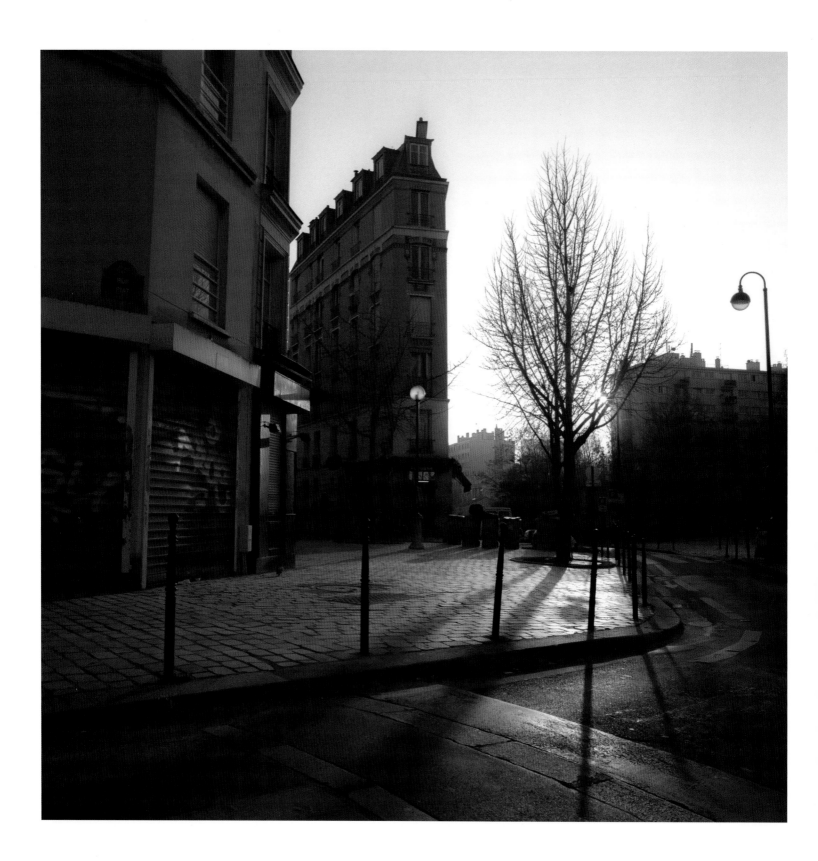

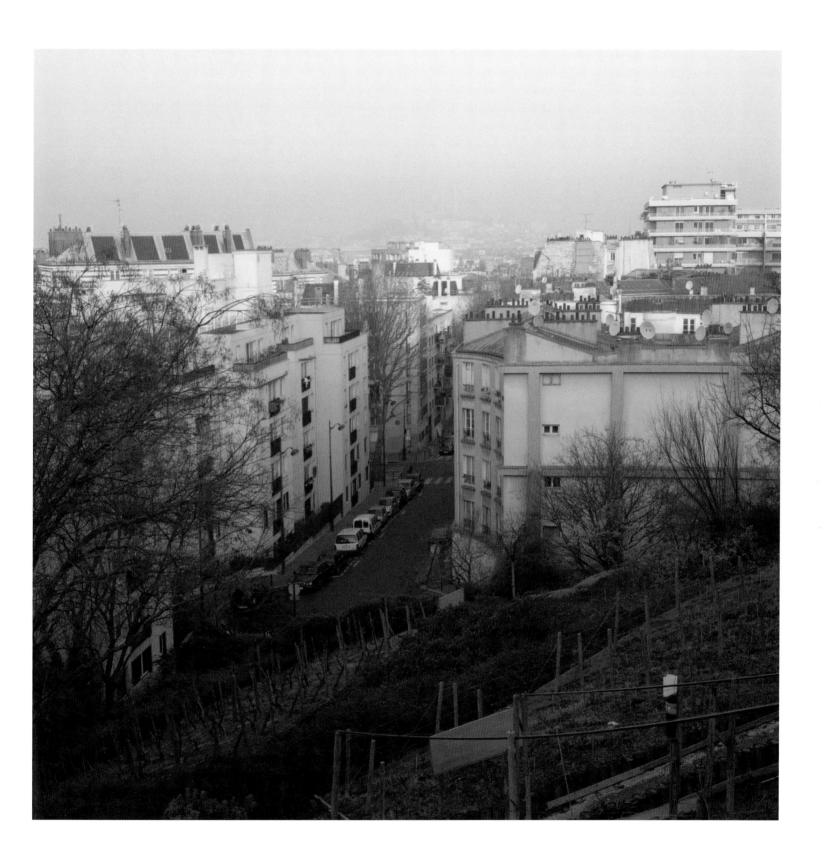

left. Rue Piat, Belleville

above. Vineyard

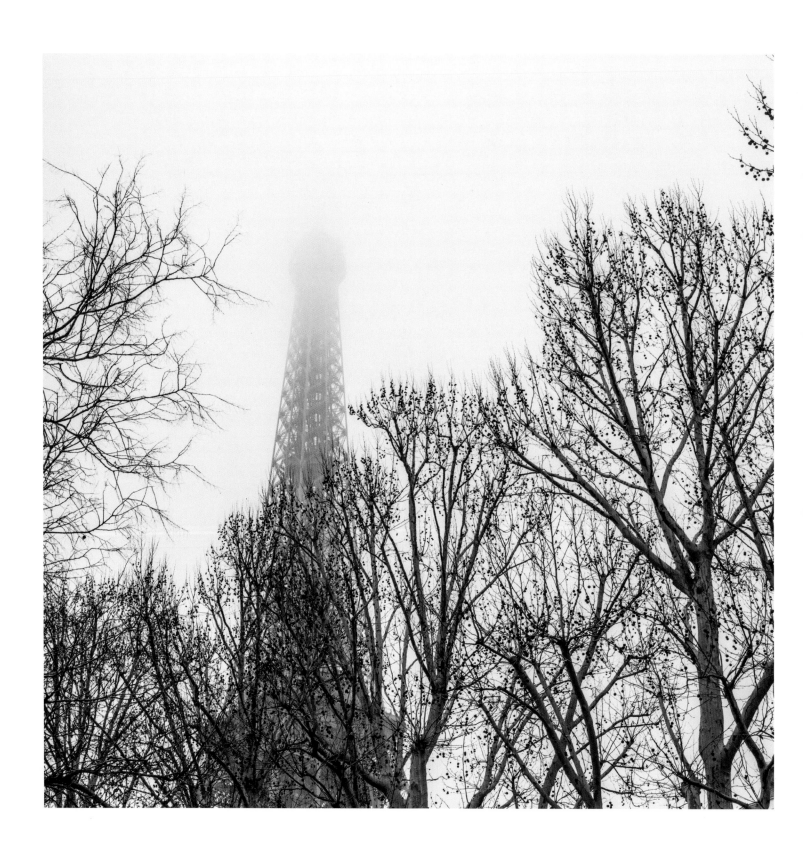

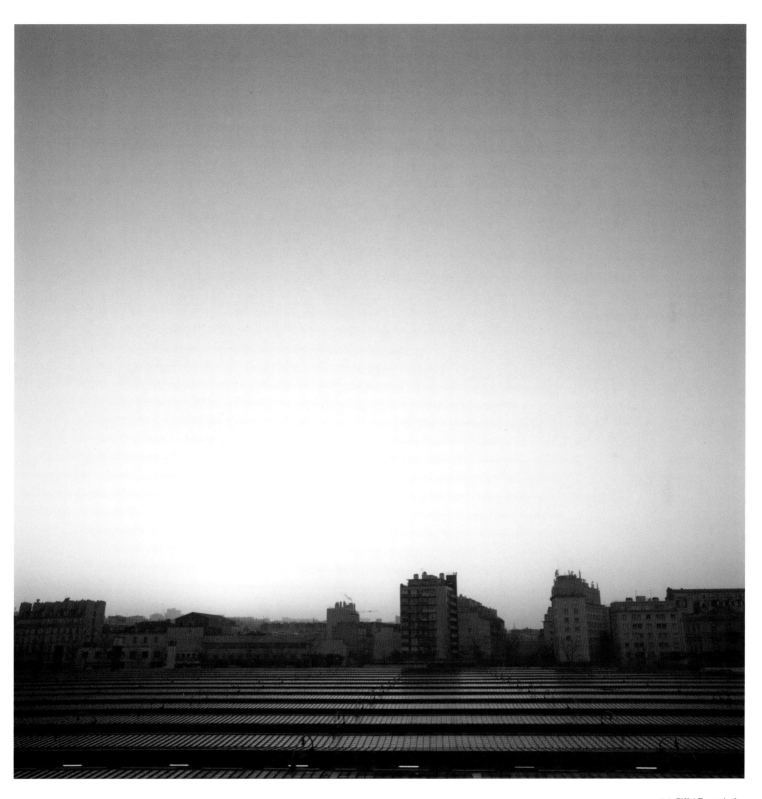

left. Eiffel Tower in fog
above. Rue d'Alsace by gare de l'Est

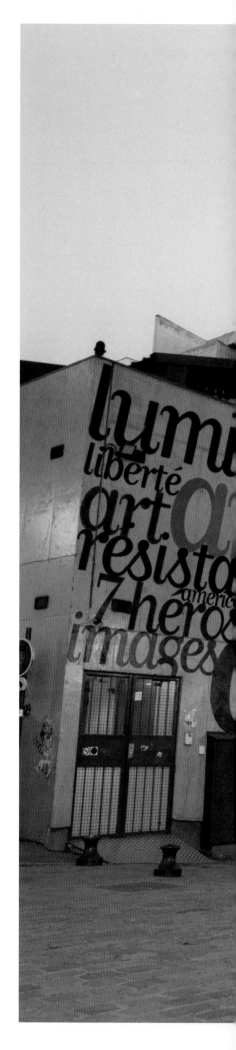

Quai de la Seine at rue de Soissons

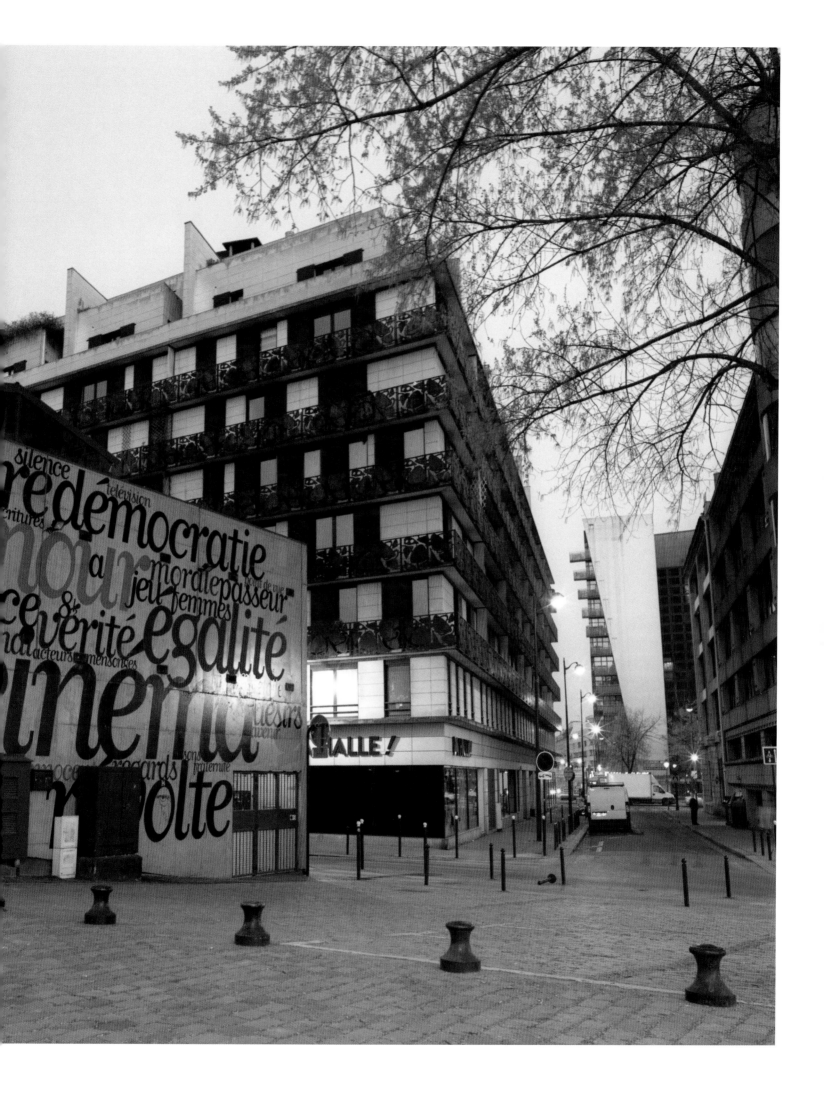

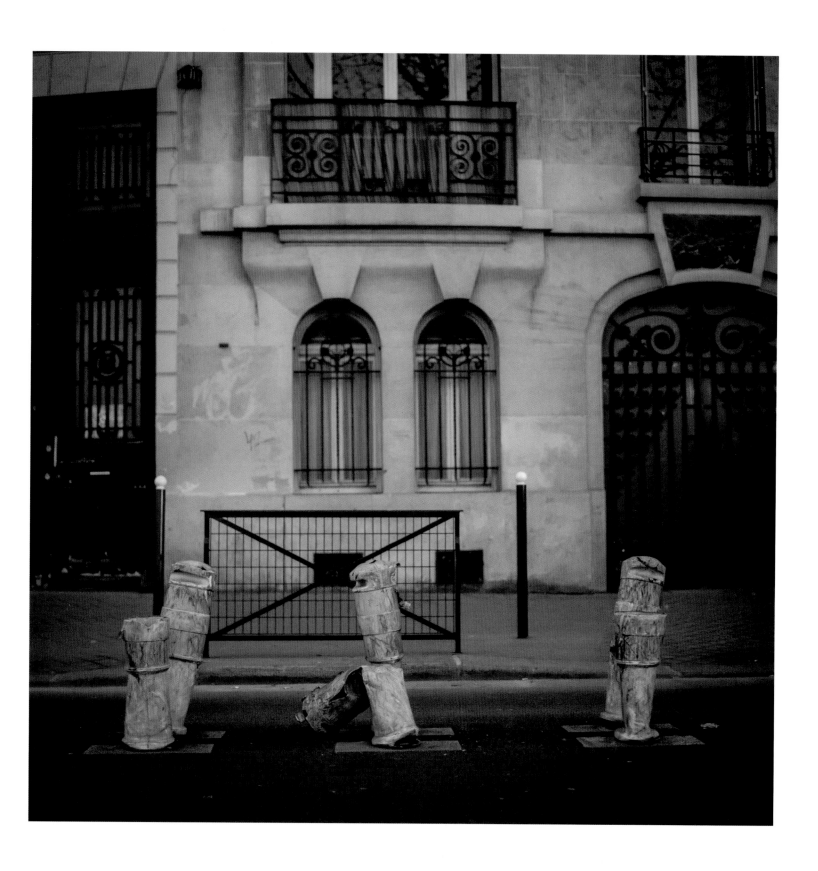

left top. Apartment detail
left bottom. First (red) light in Pigalle
above. Broken barrier

over. Barrière du Trône, Place de la Nation

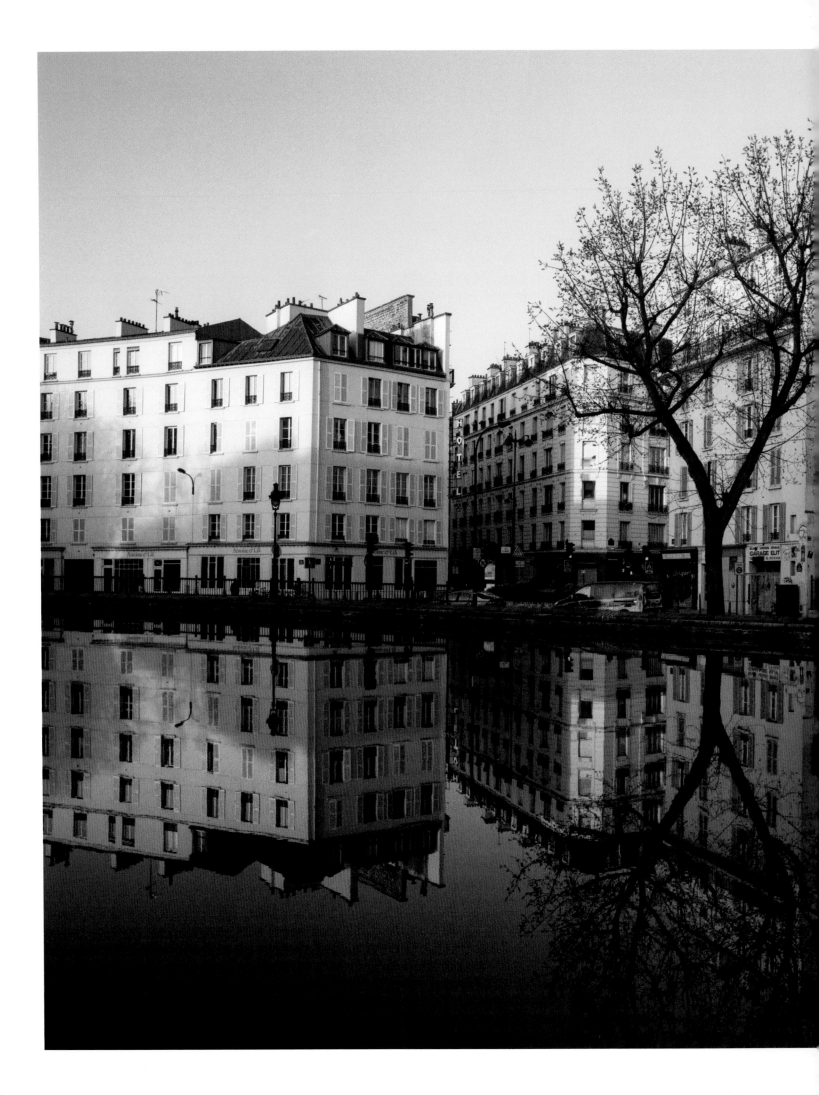

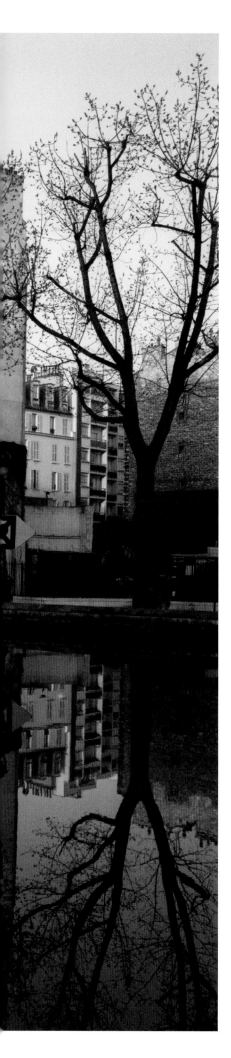

left. Quai de Valmy, Canal Saint-Martin

over. Fruit trees, Chemin de fer de Petite Ceinture

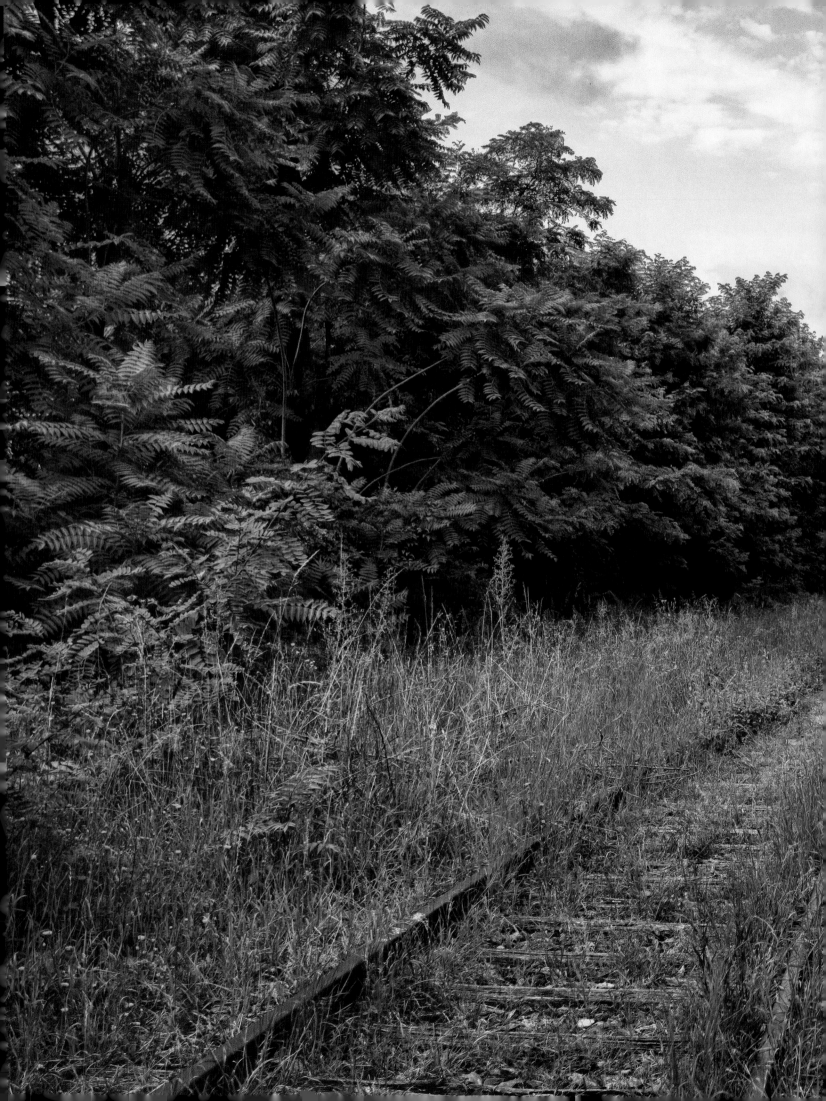

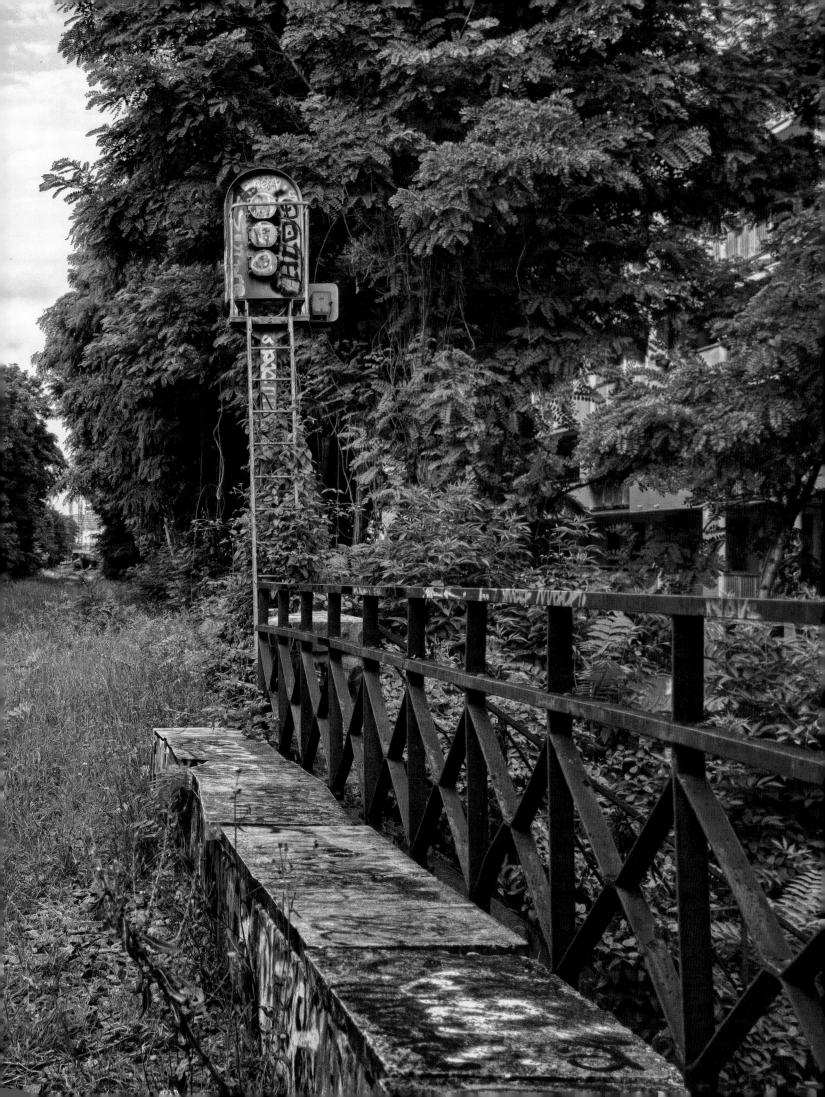

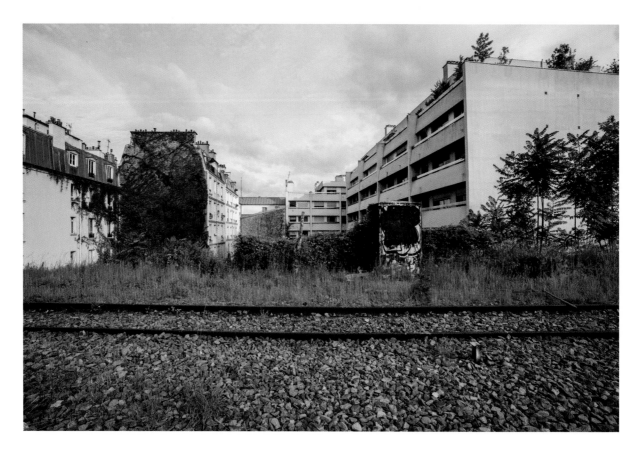

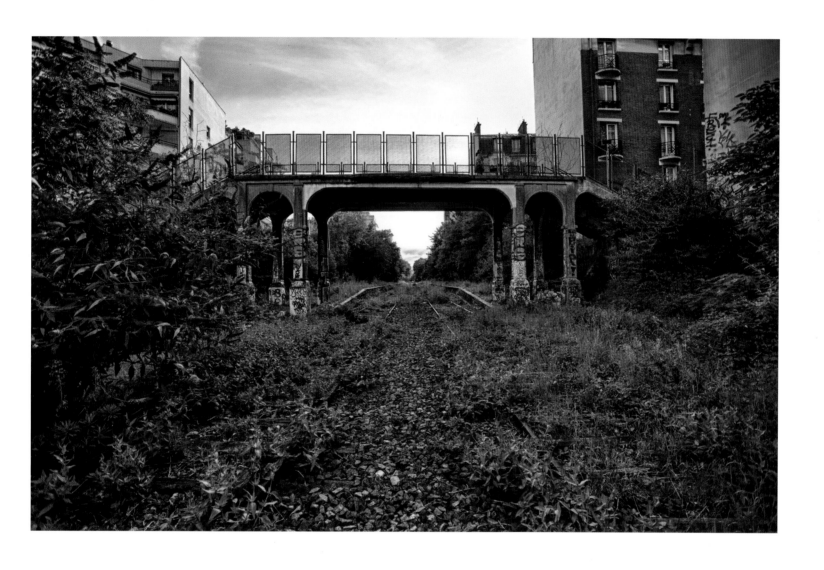

left top. Cat bed
left bottom. Straight tracks

above and over. Chemin de fer de Petite Ceinture

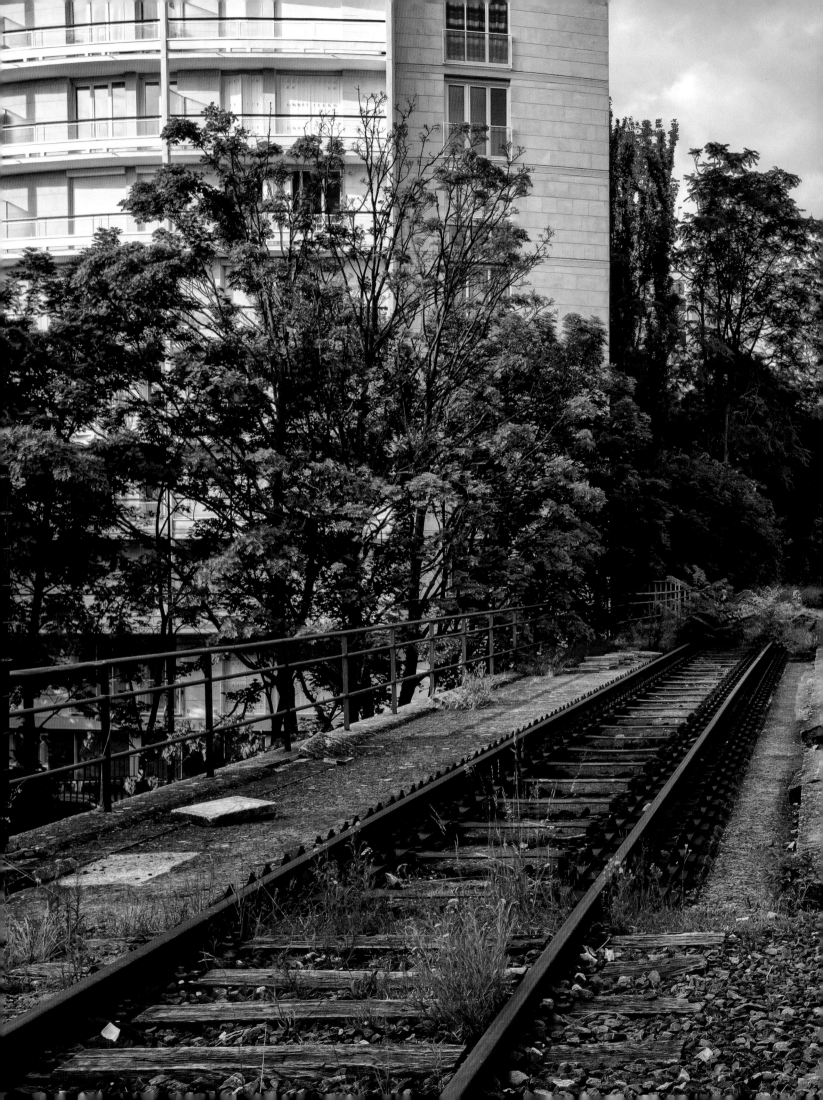

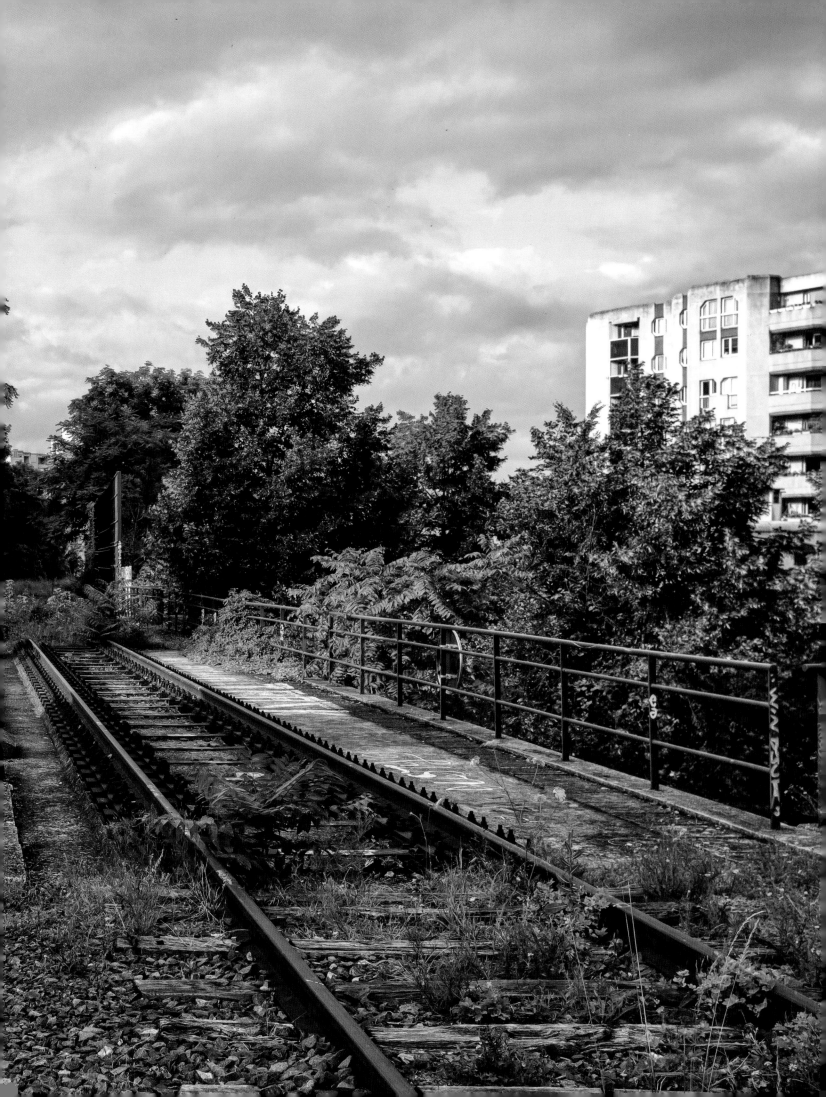

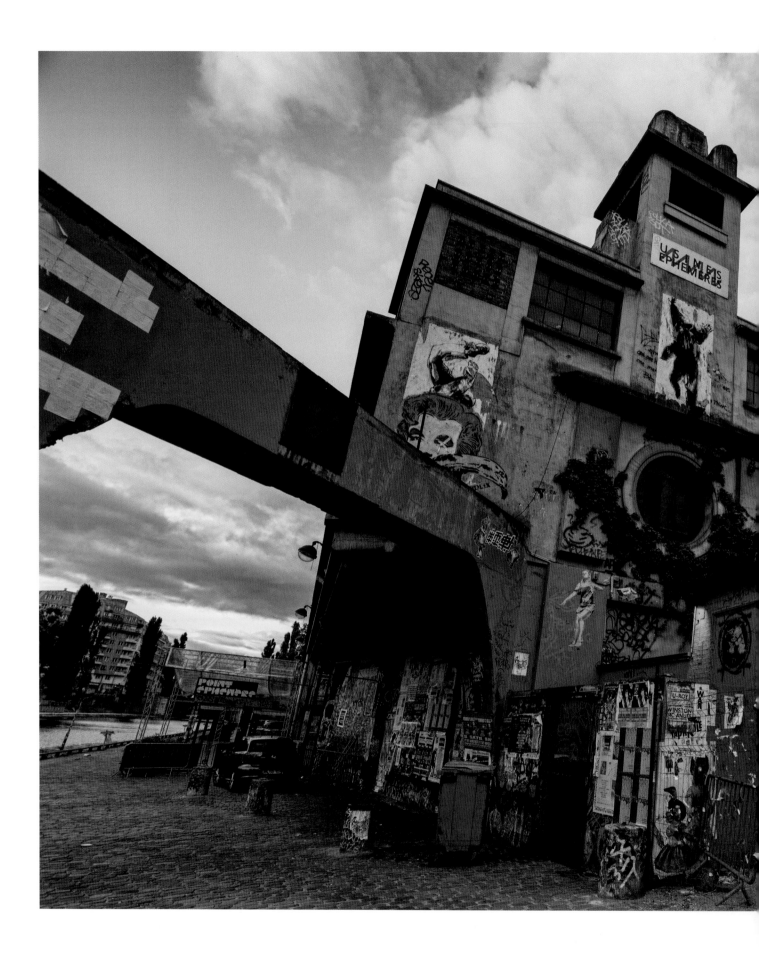

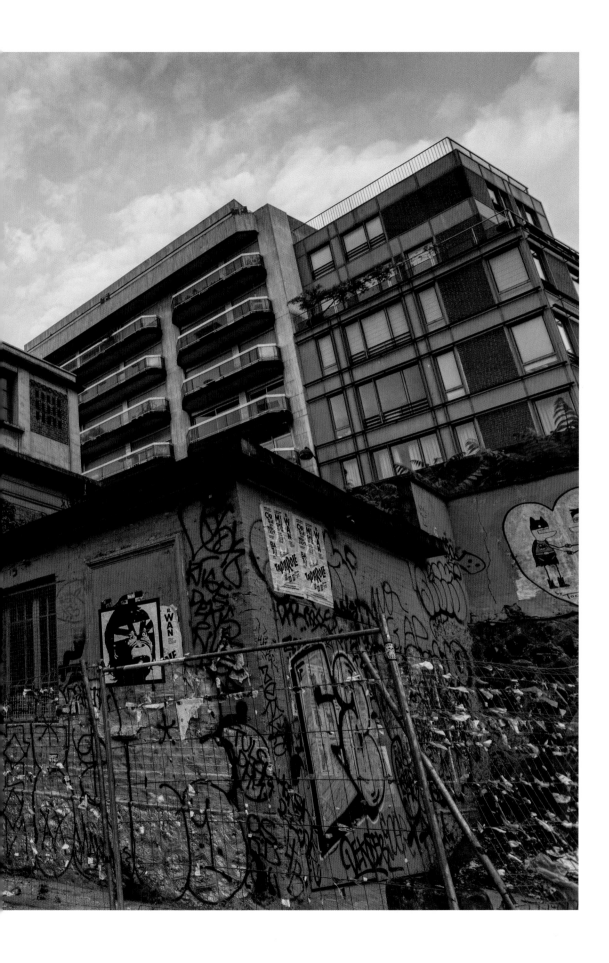

left. Graffiti on Canal Saint-Martin

over Underpass with graffiti

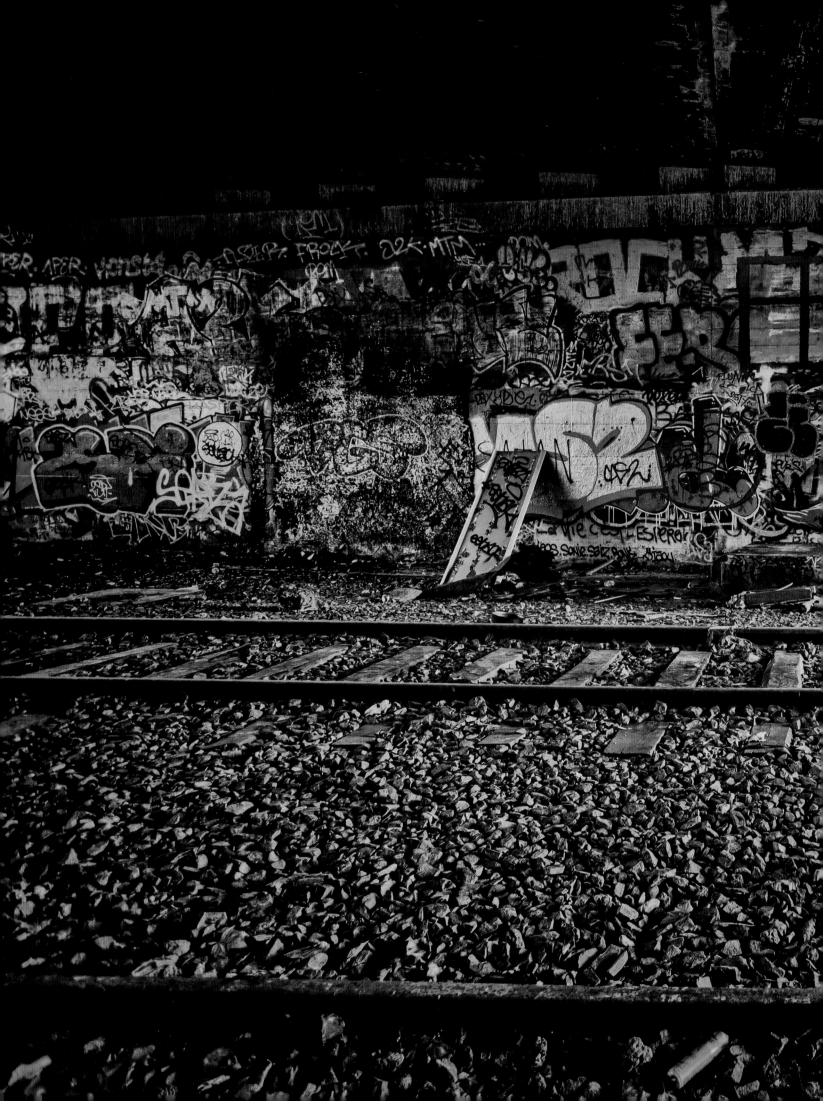

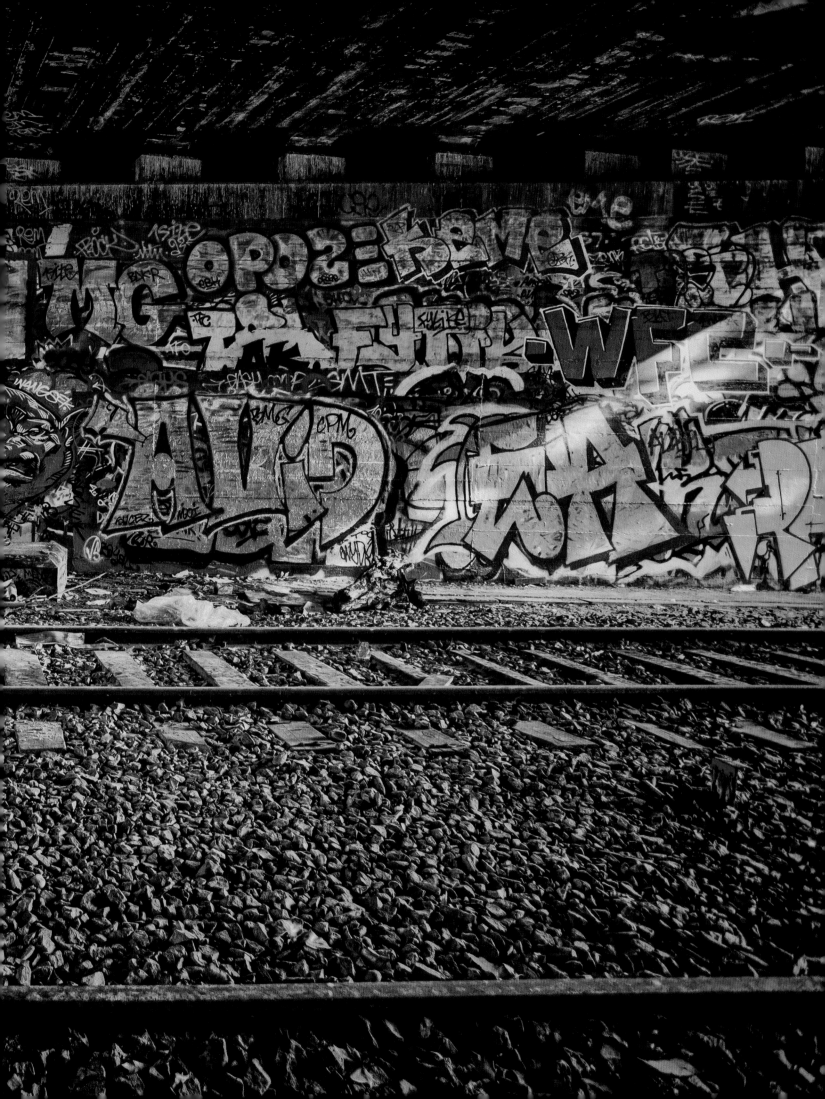

left. Saturday morning

above. Rue Jeanne d'Arc

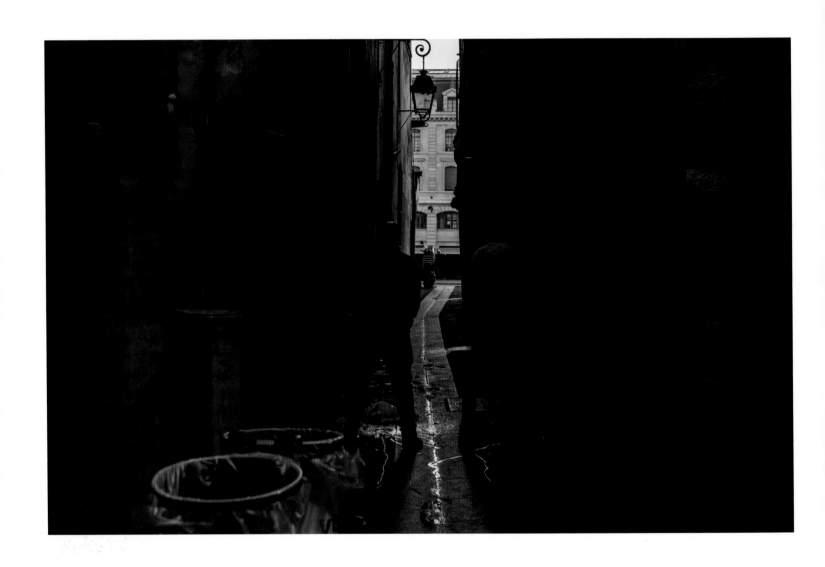

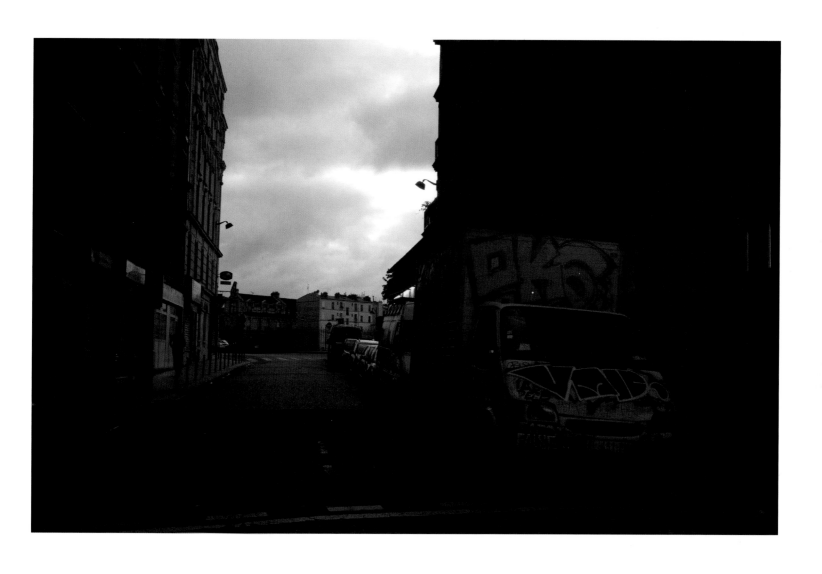

left. After a long night
above. Around Barbès

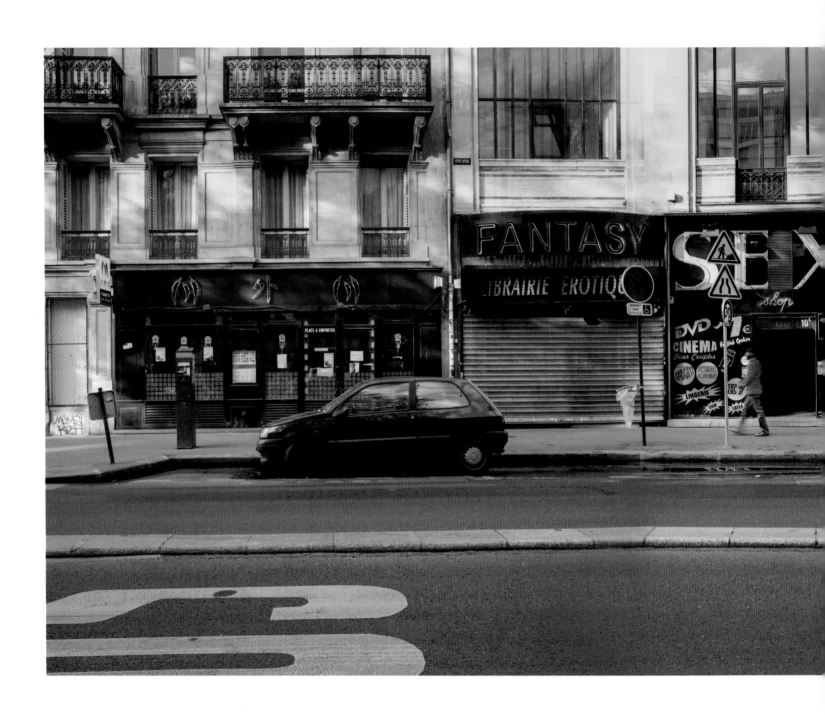

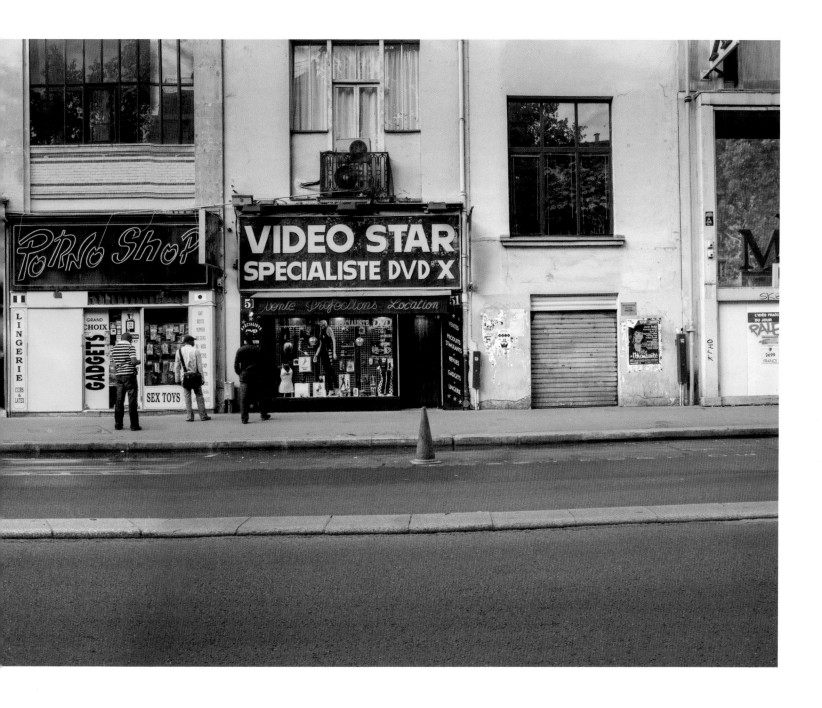

Red light, grey dawn

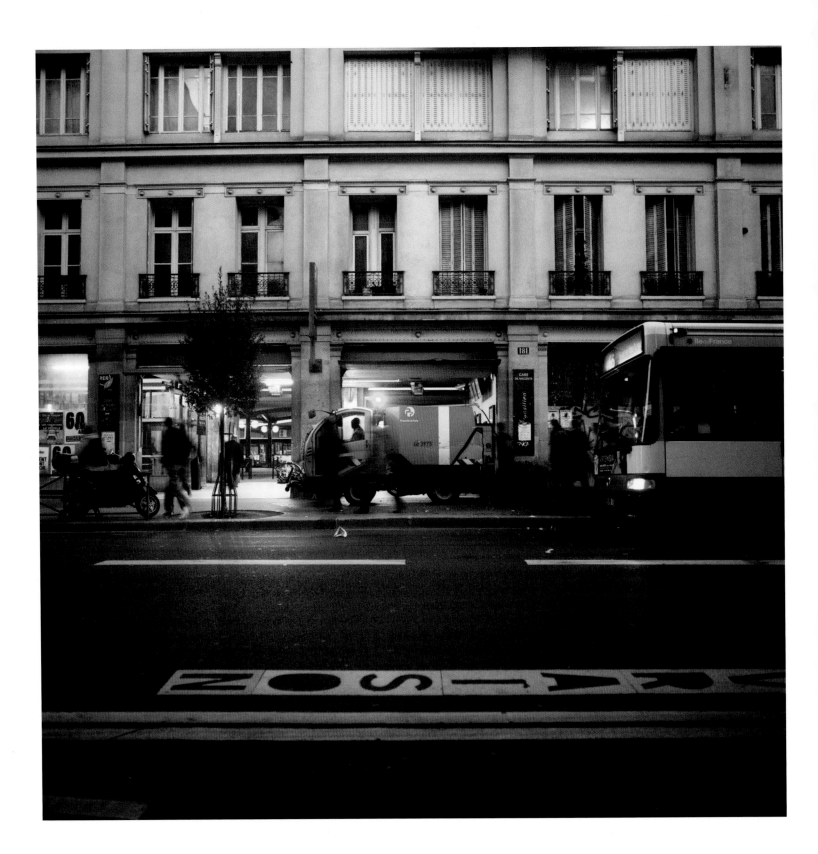

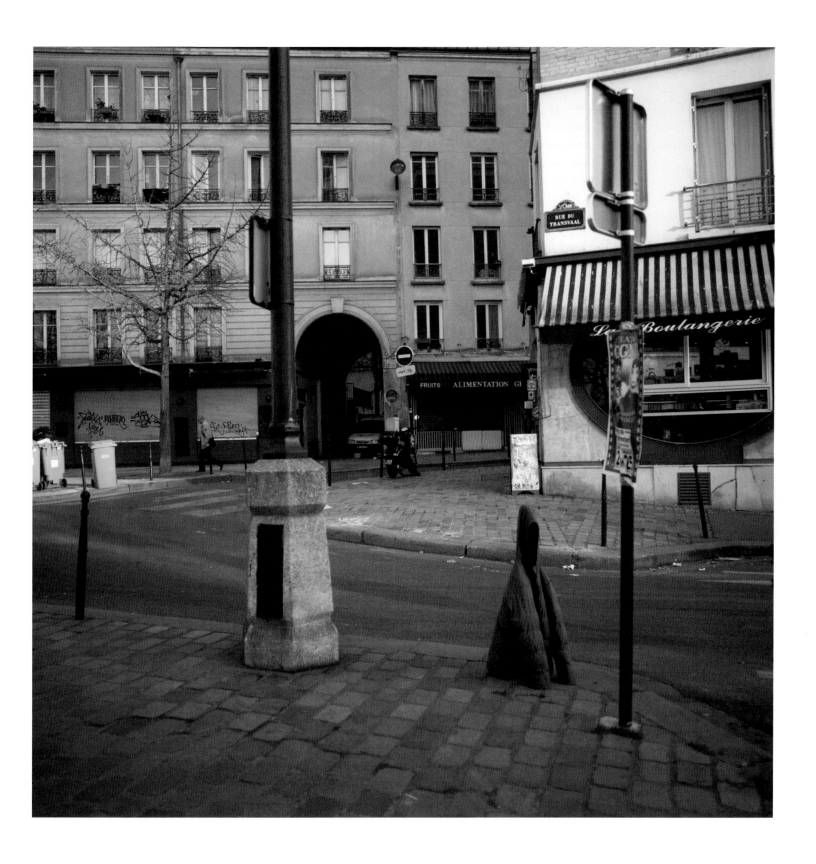

left. Early morning shift
above. Rue du Transvaal

over. La Défense

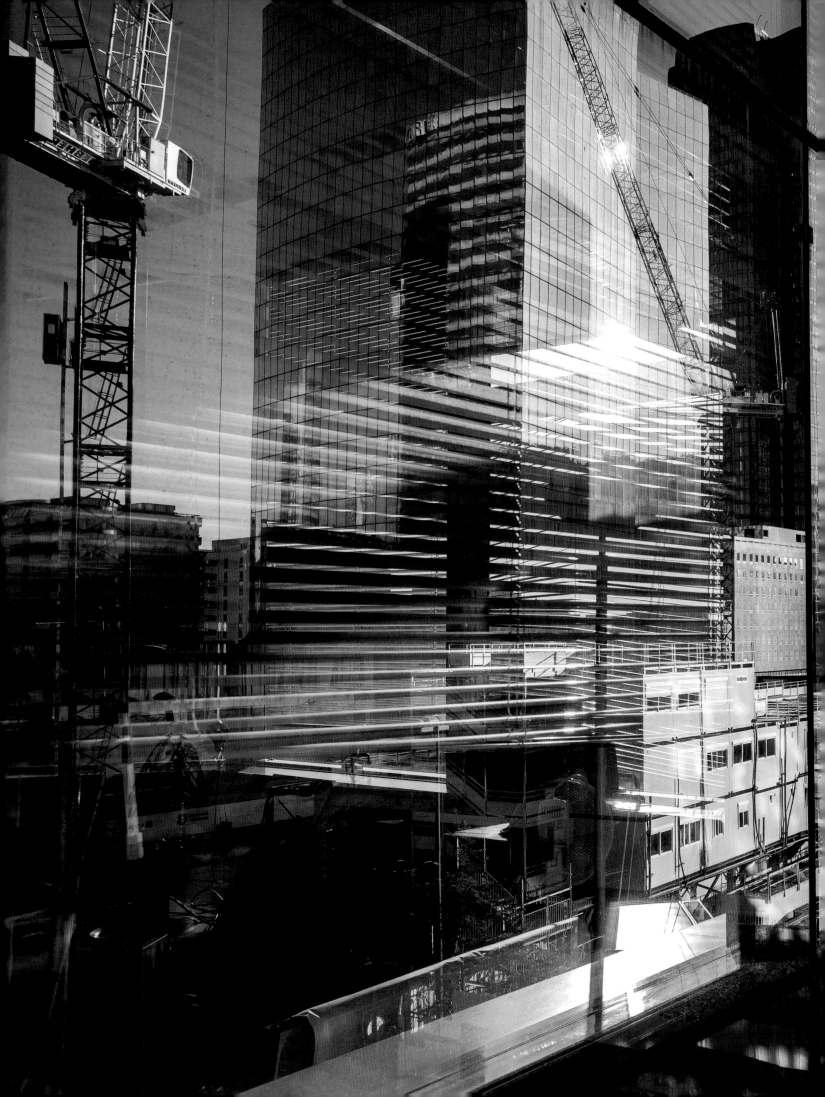

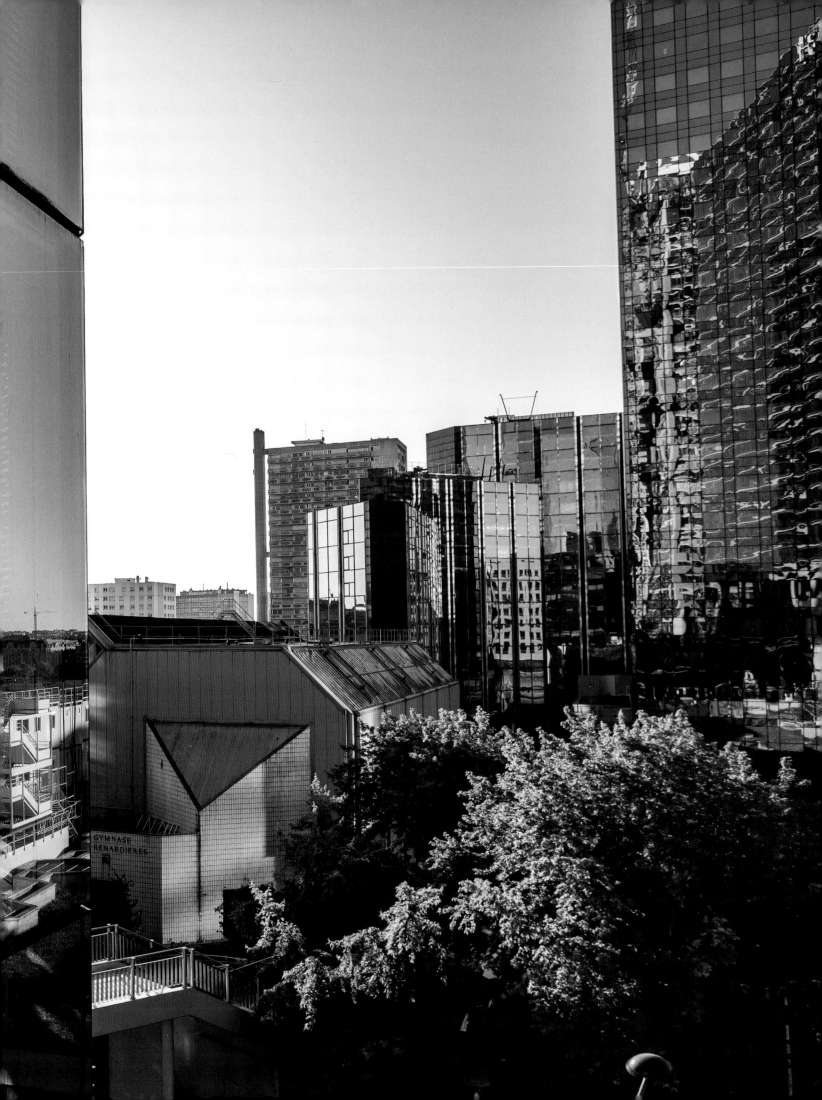

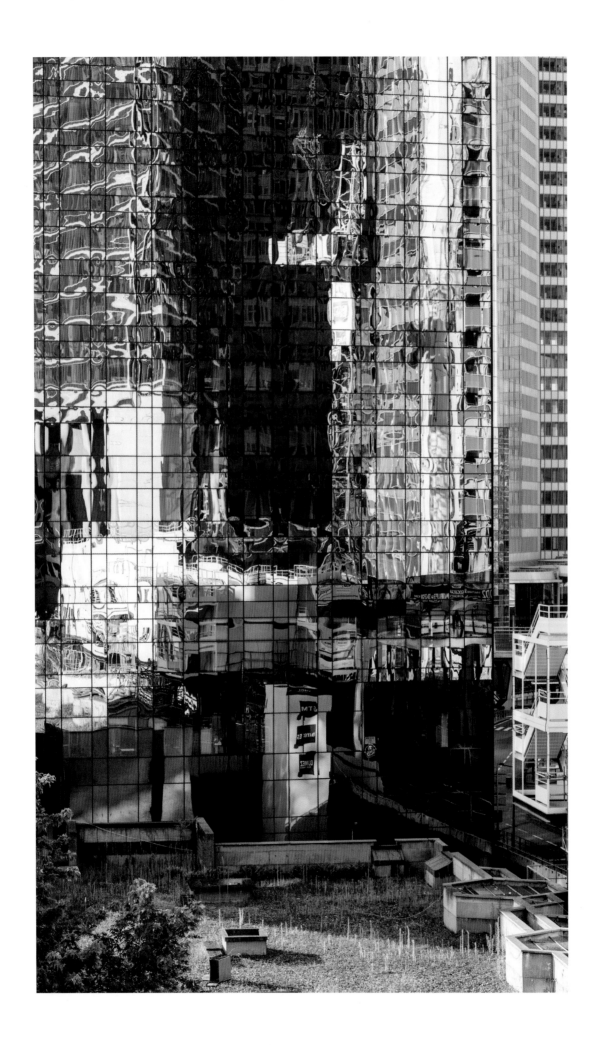

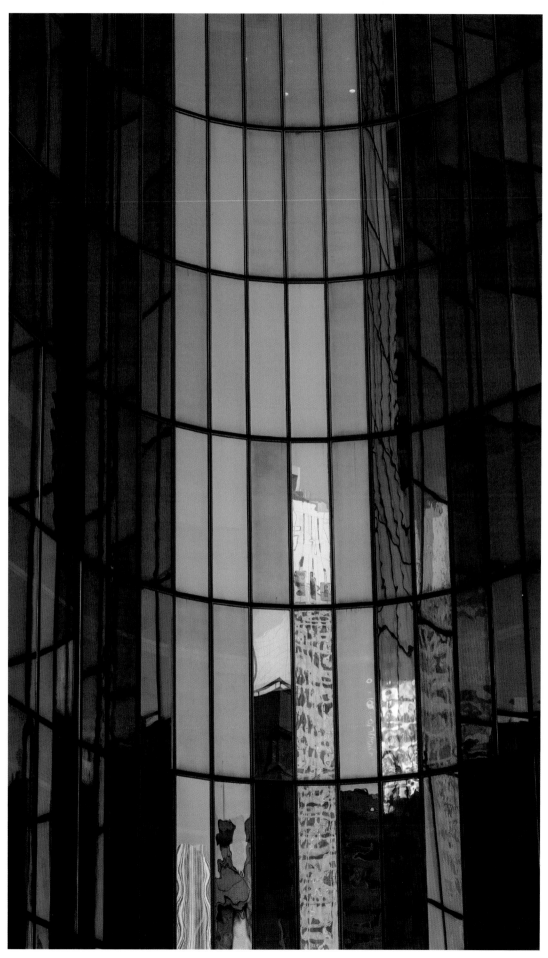

left. Detail #1 La Défense
above. Detail #2 La Défense

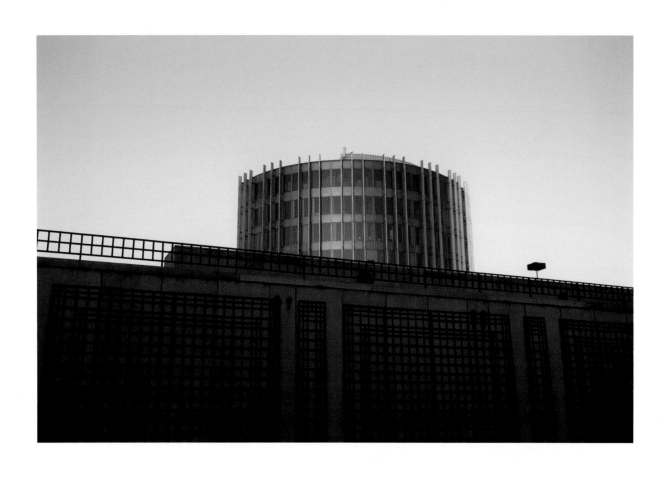

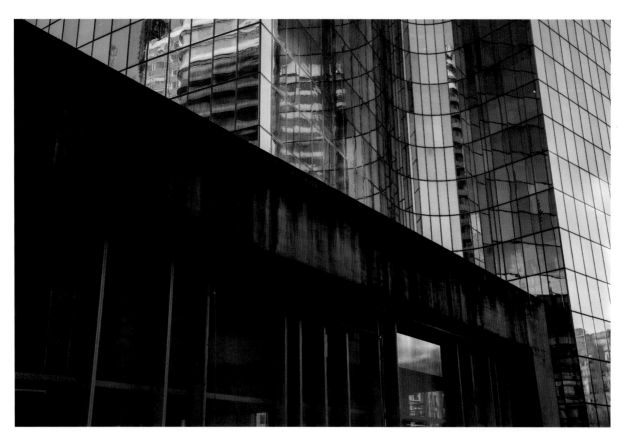

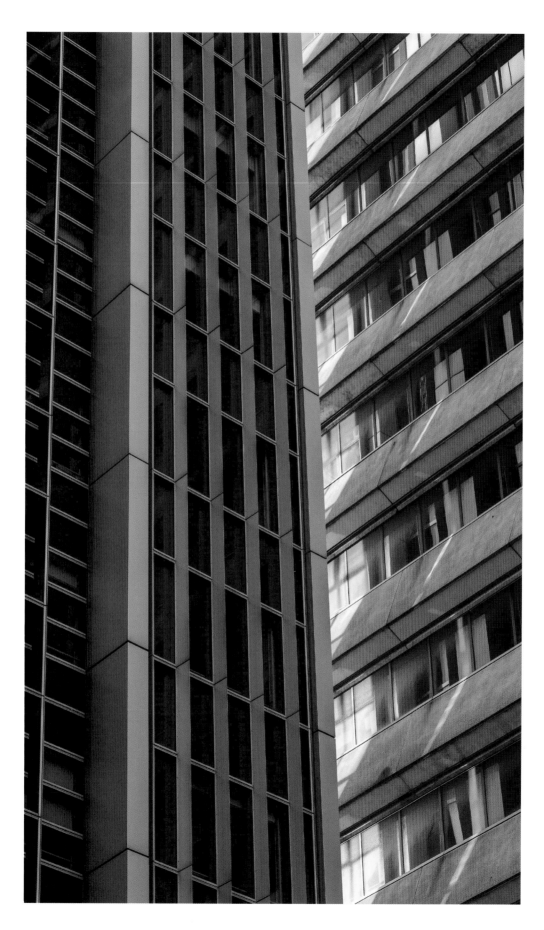

left top. Detail #3 La Défense
left bottom. Detail #4 La Défense
above. Detail #5 La Défense

over. La Défense

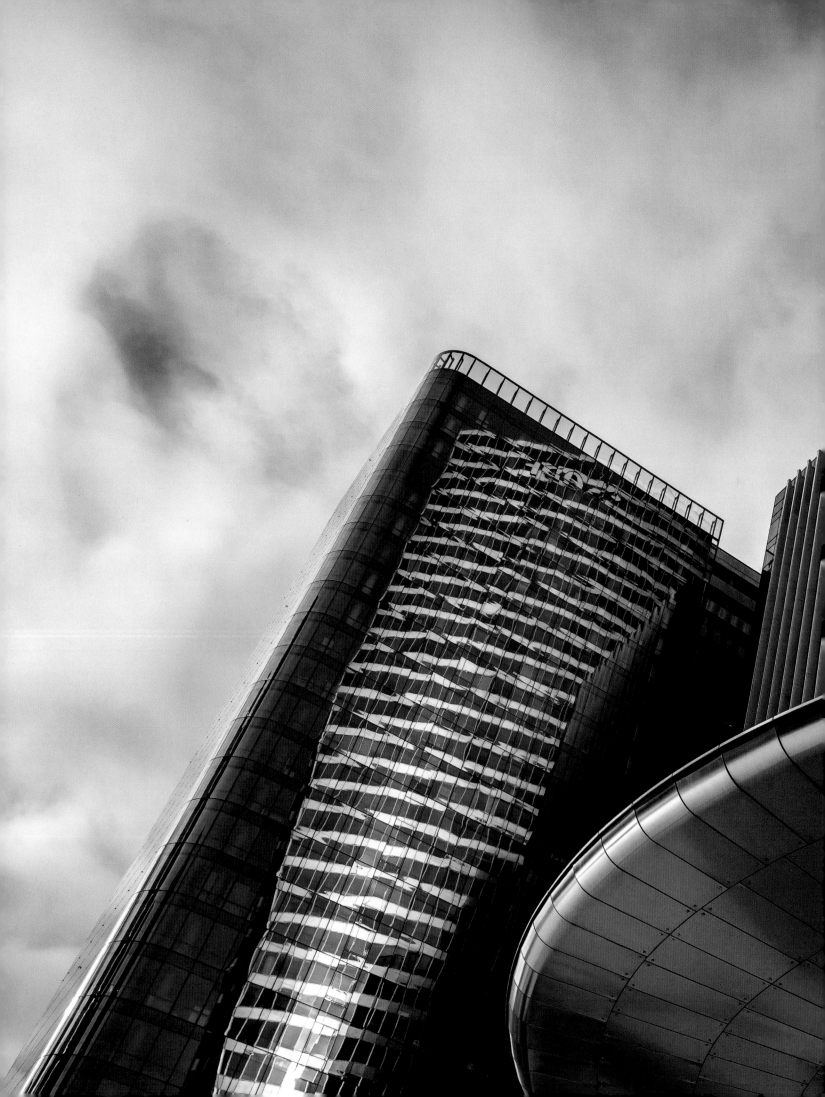

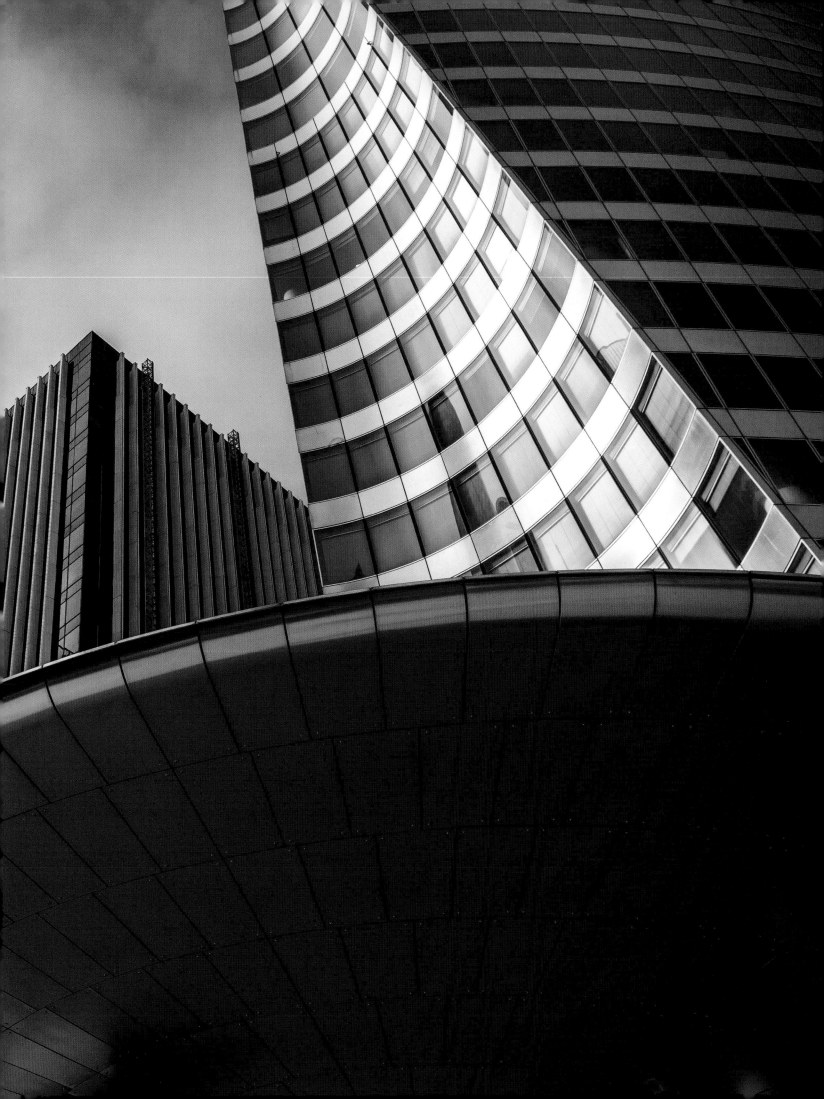

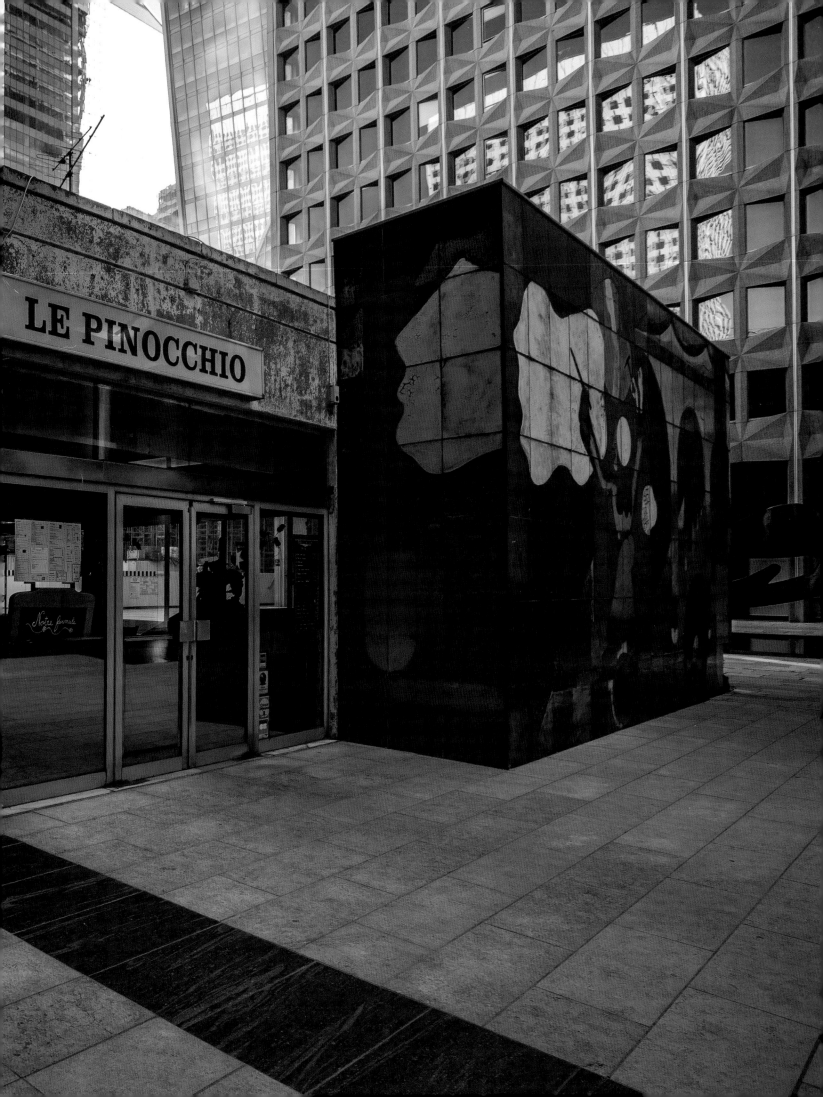

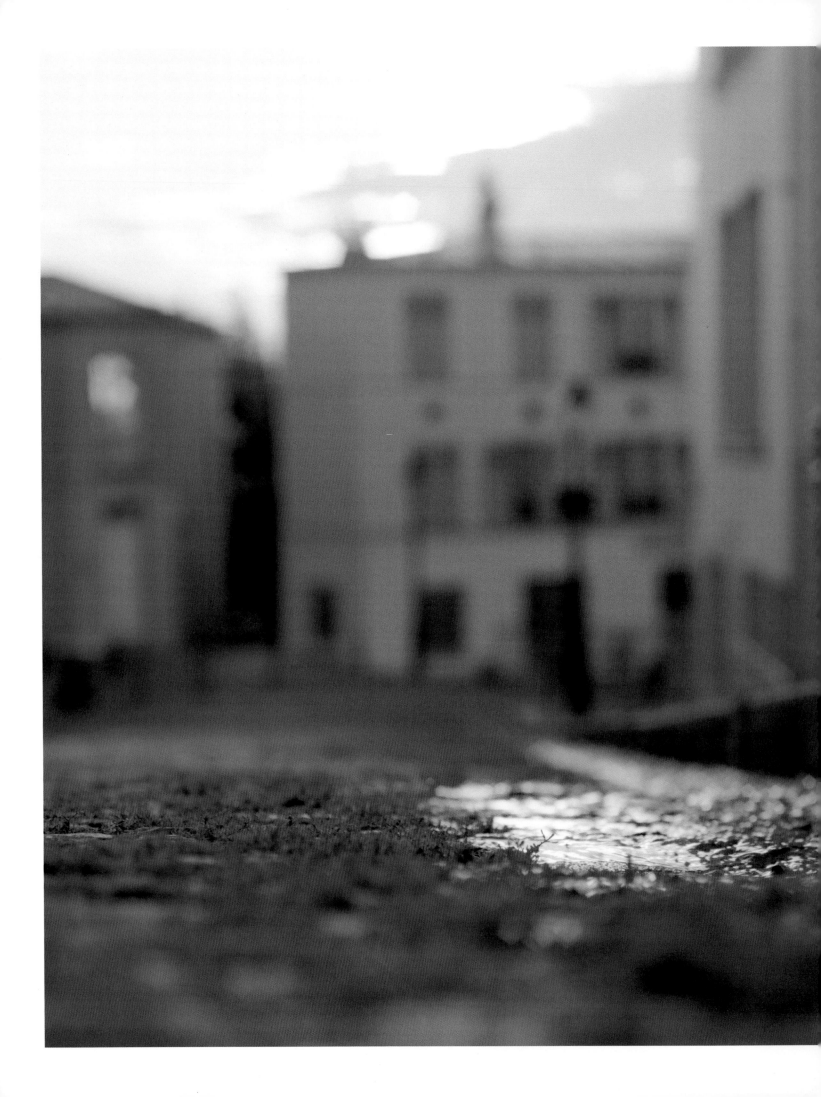

previous spread. Pizzeria, La Défense

left. Wet street

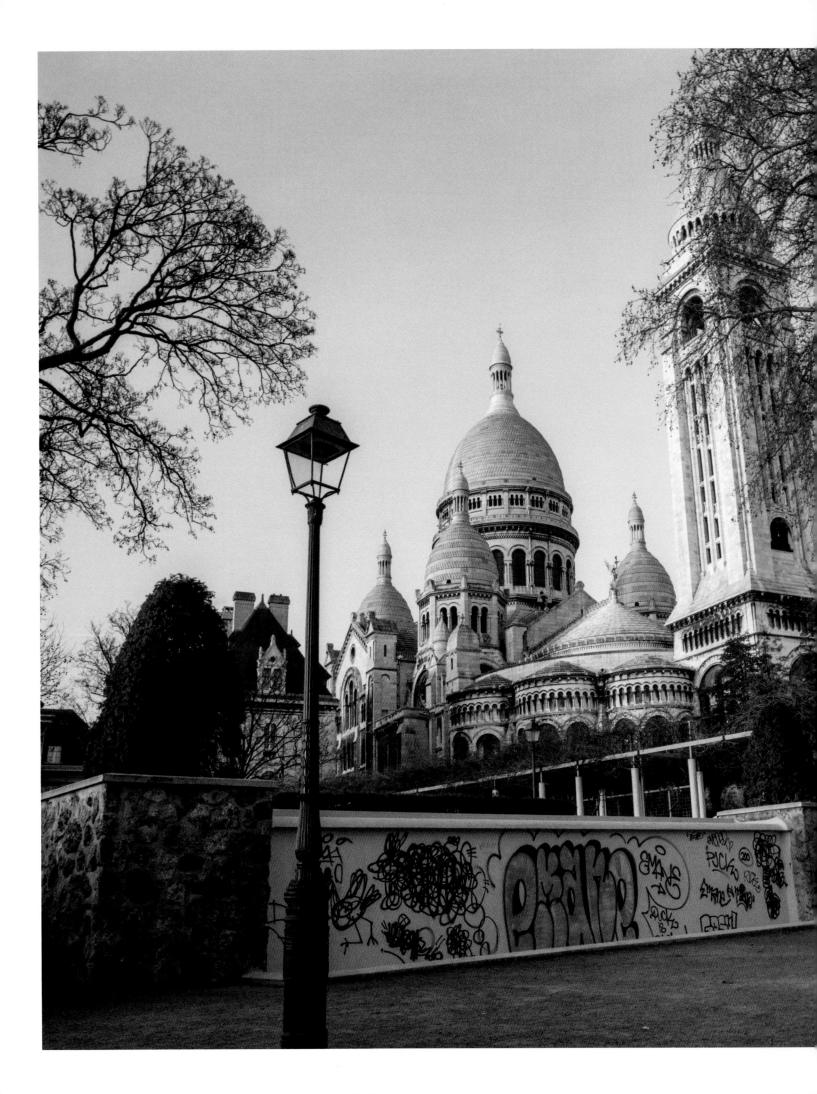

left. Basilique du Sacré-Cœur

over. Park path leading to Basilique du Sacré-Cœur

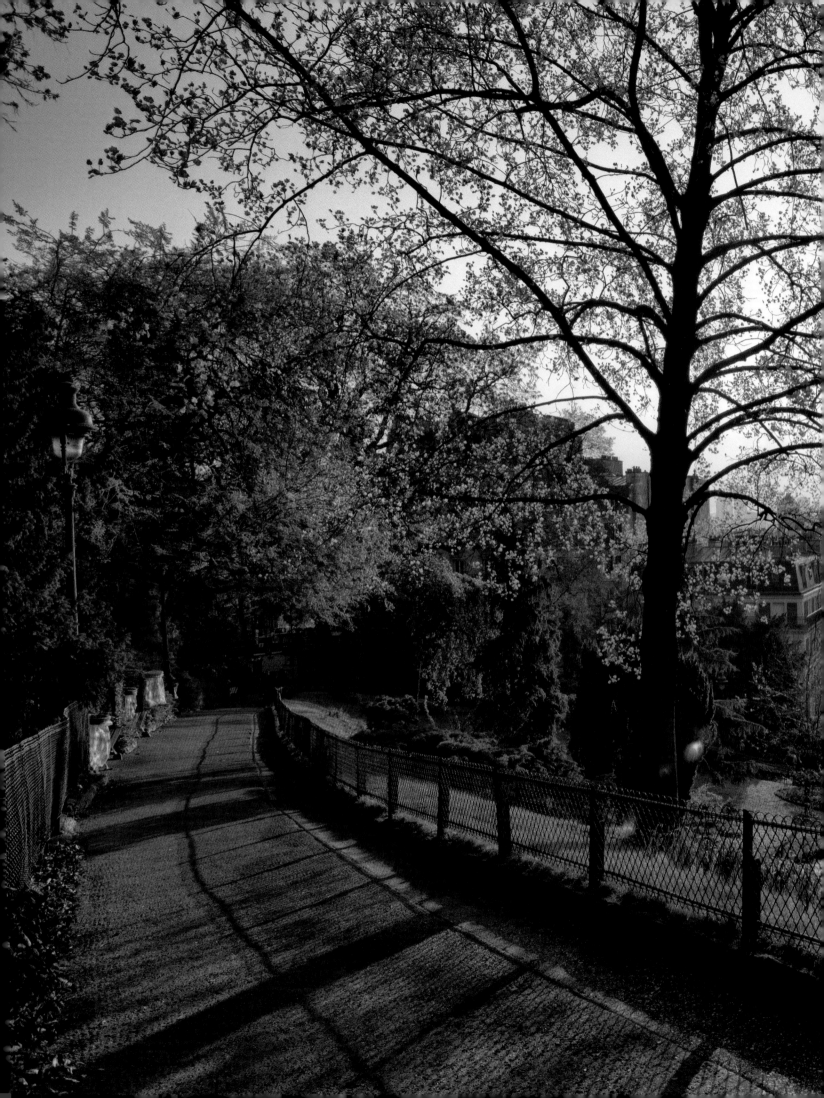

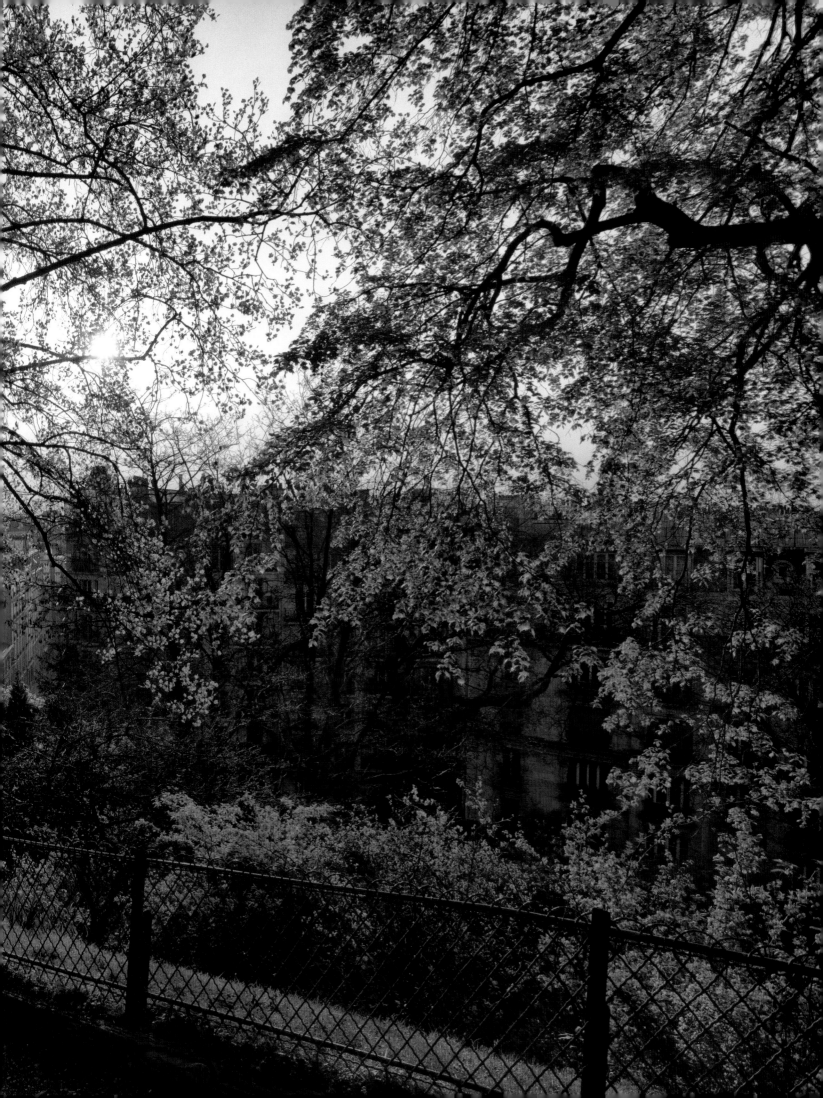

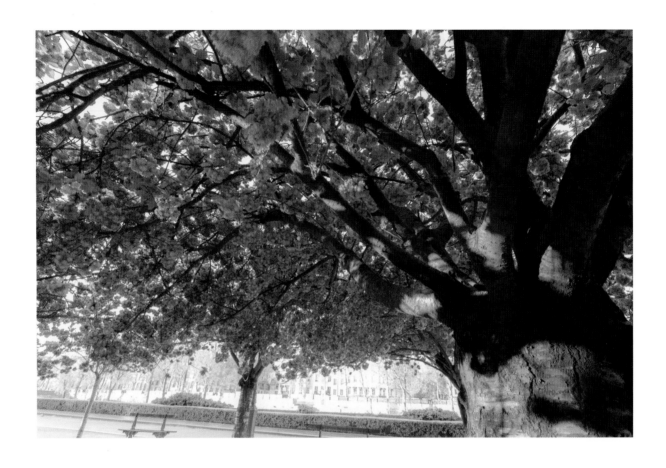

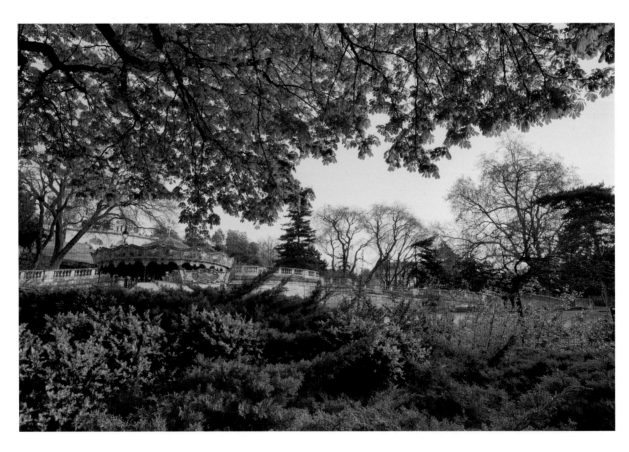

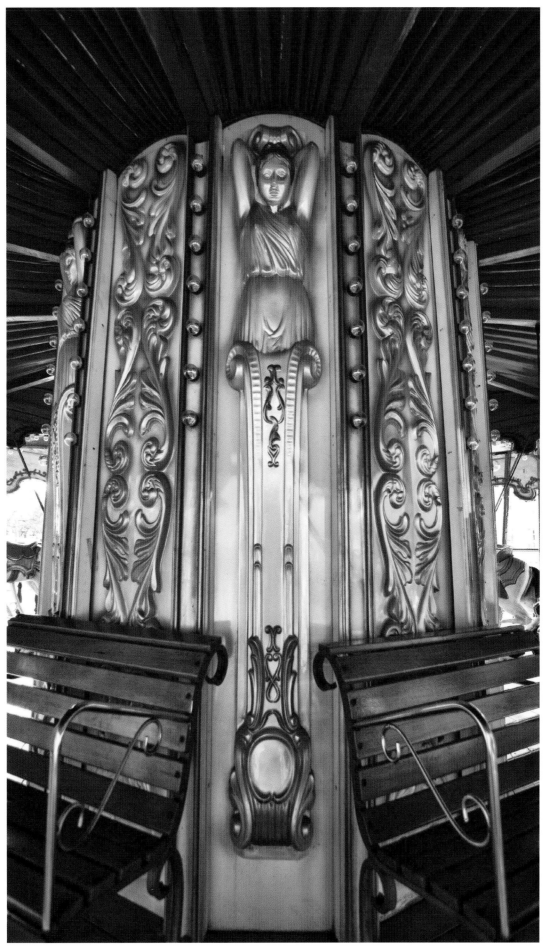

left top. Square Jean XXIII

left bottom. View from Square Louise-Michel

above. Carousel

White cat of Montmartre

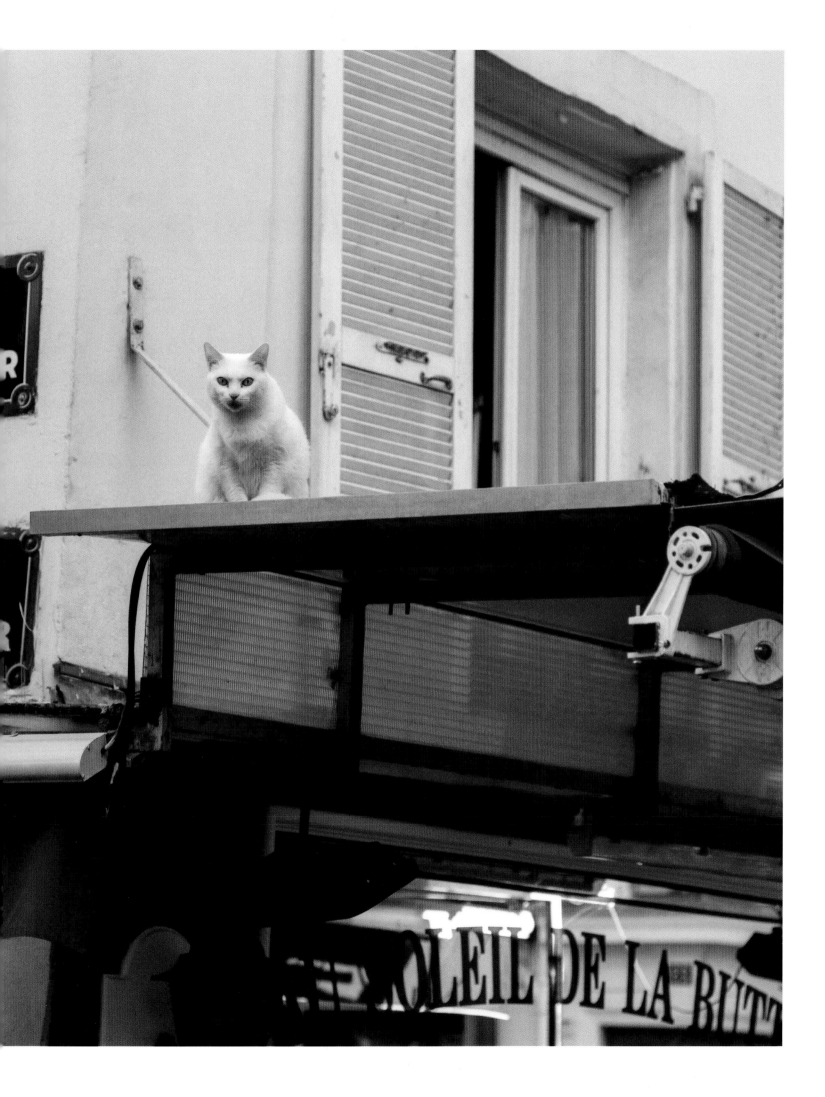

The Butcher

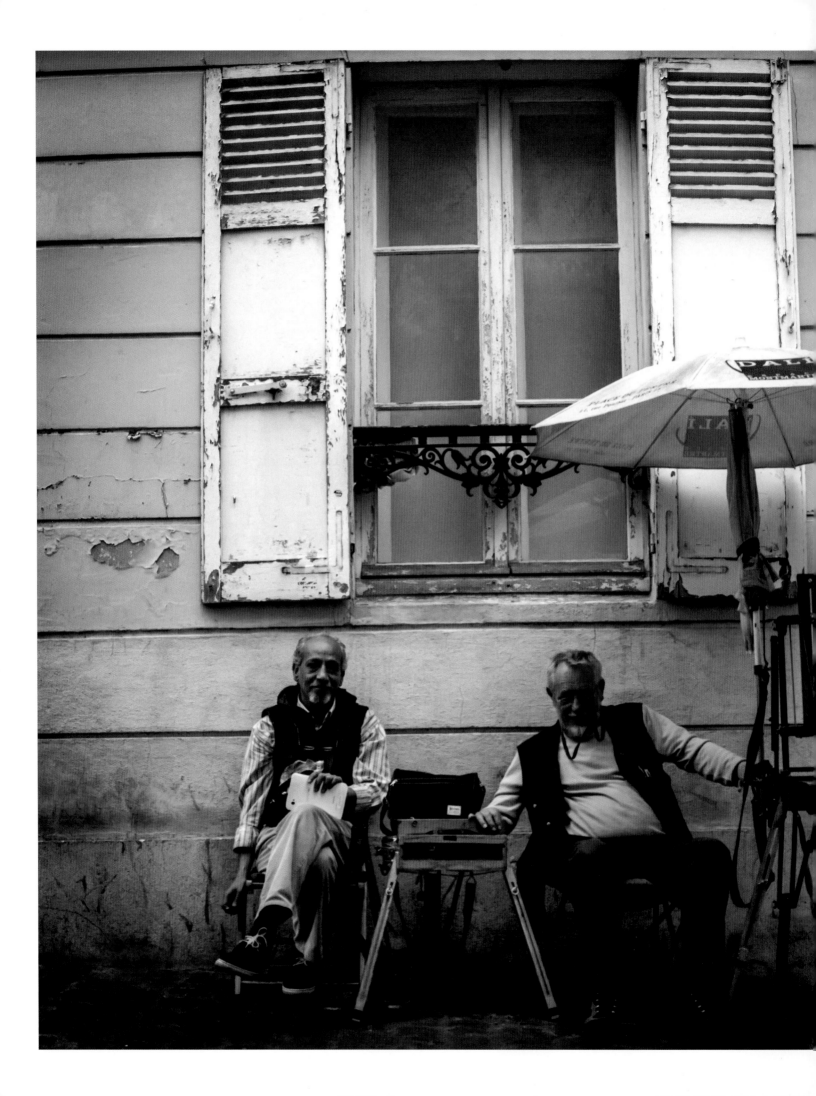

Artists of Place du Tertre

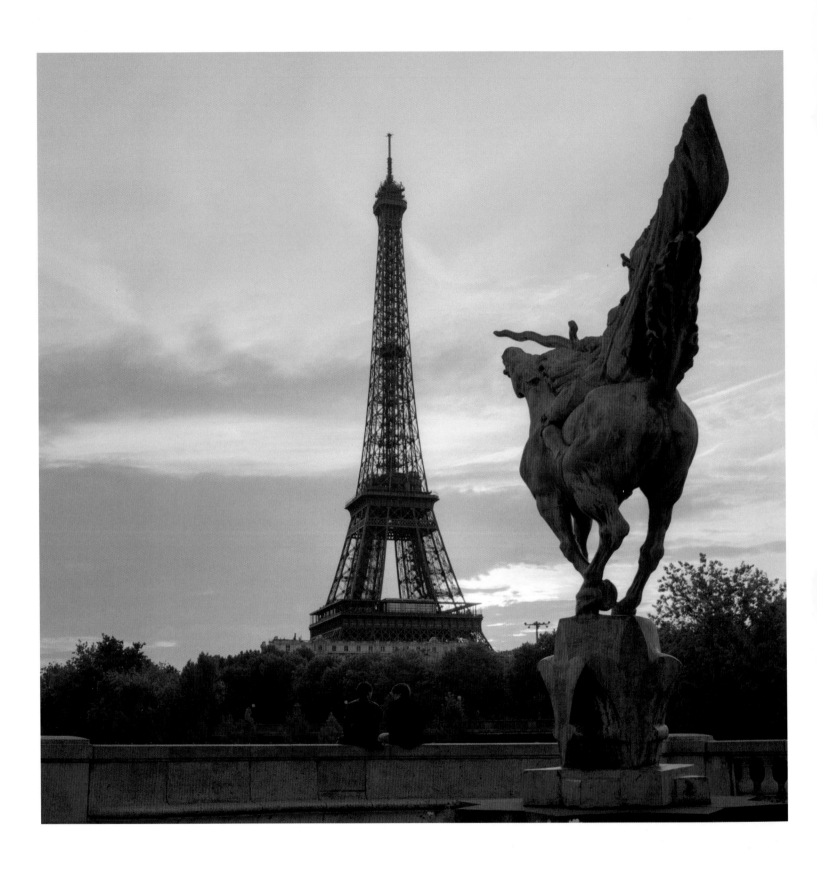

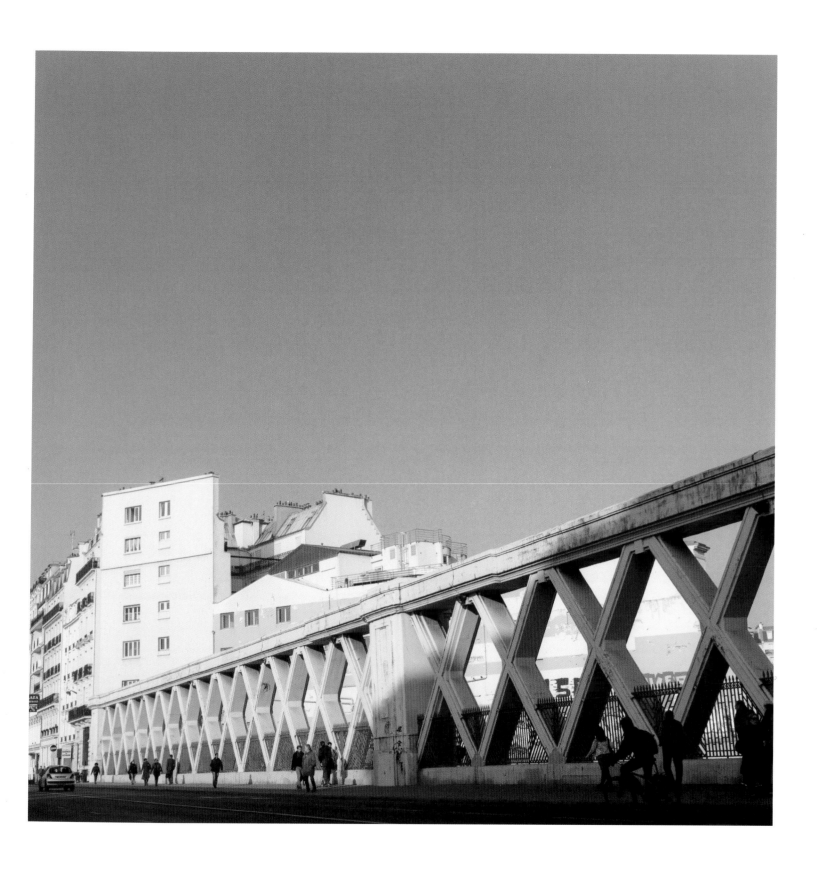

left. Eiffel Tower from Bir-Hakeim

above. Rue la Fayette over gare de L'Est

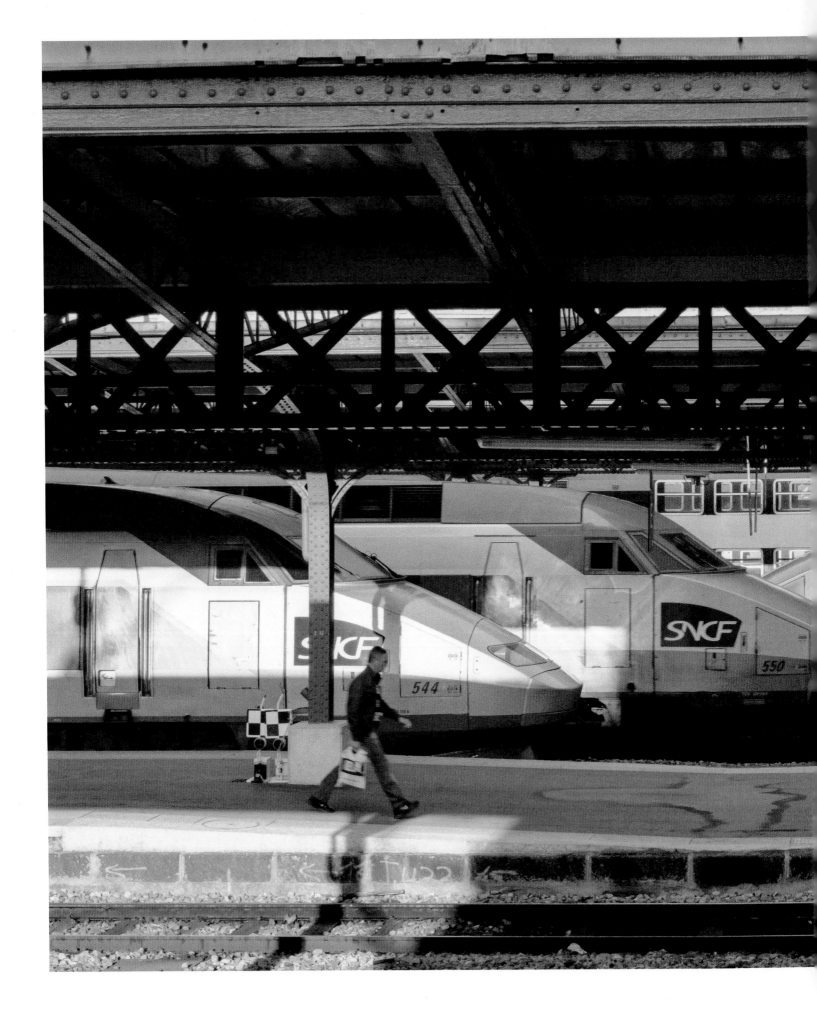

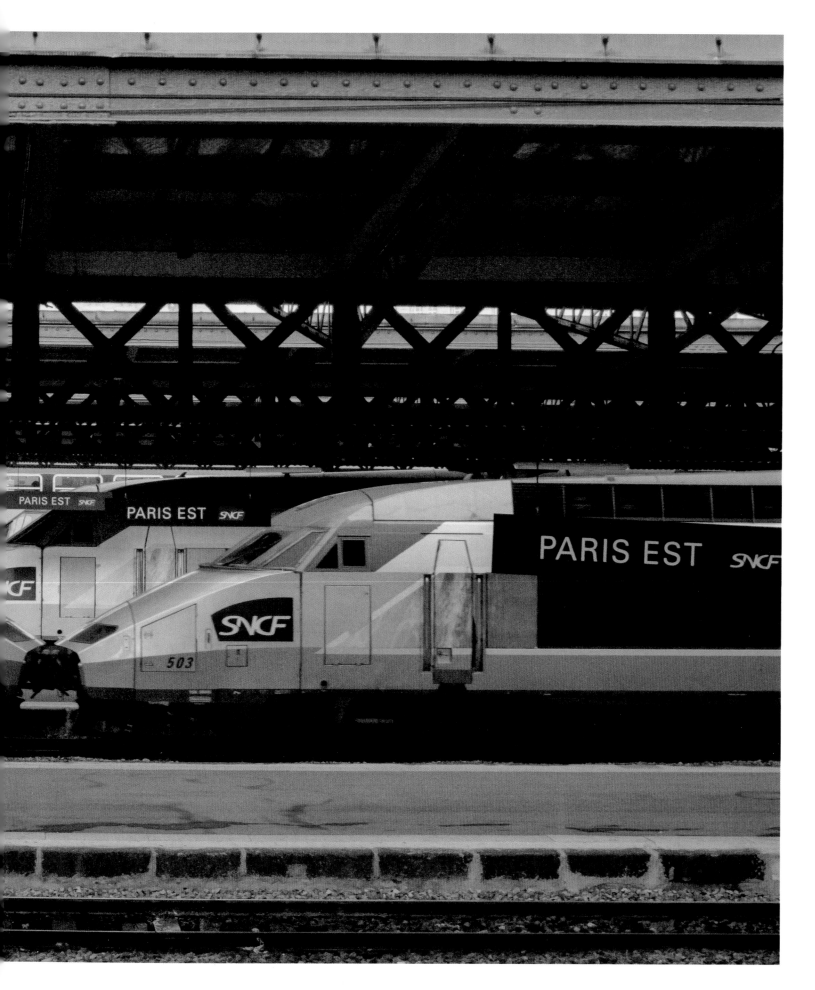

Early commuter, gare de l'Est

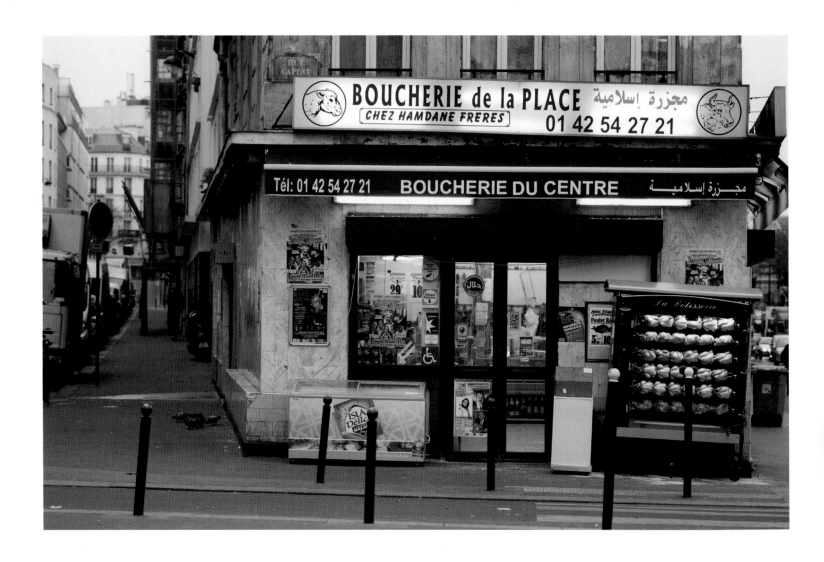

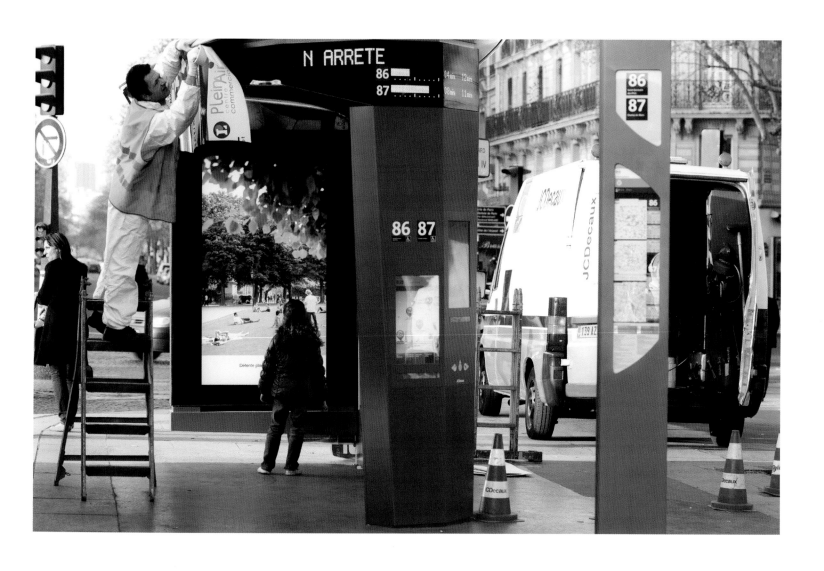

left. Rotisserie, boulevard de la Chapelle
above. Bus stop at Place de la Bastille

over. Quai de la Seine

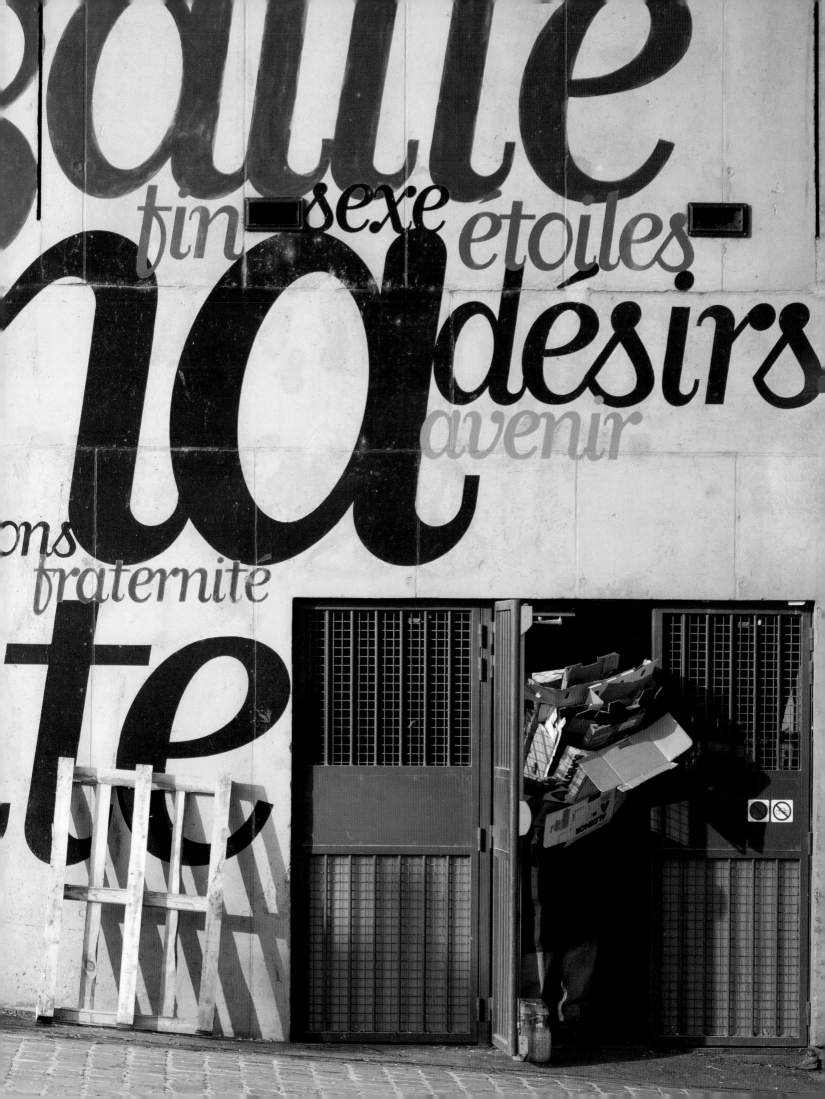

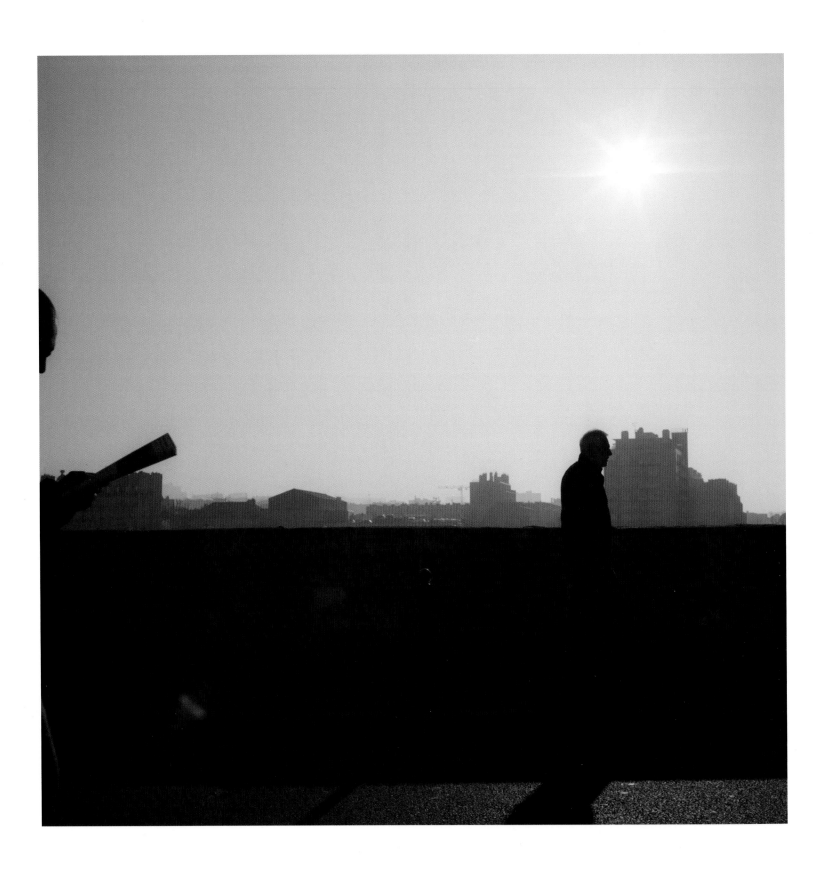

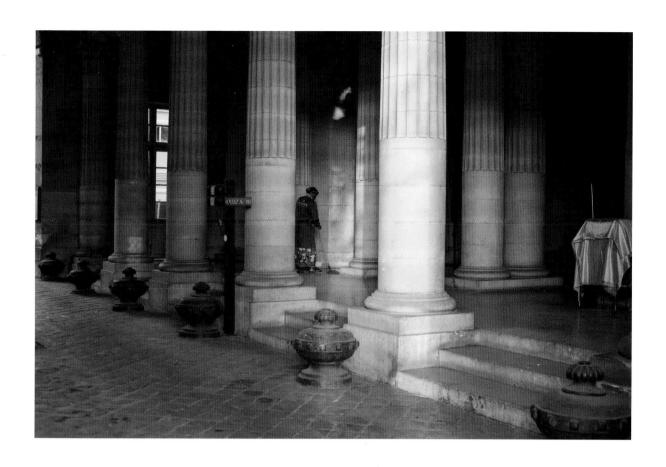

left. Rue d'Alsace by gare de l'Est
above top. The cleaning lady
above bottom. Man and red door

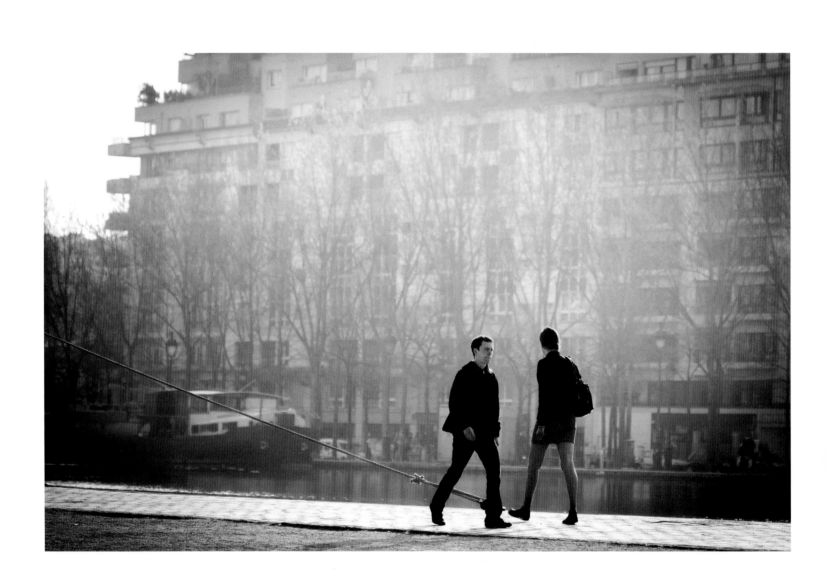

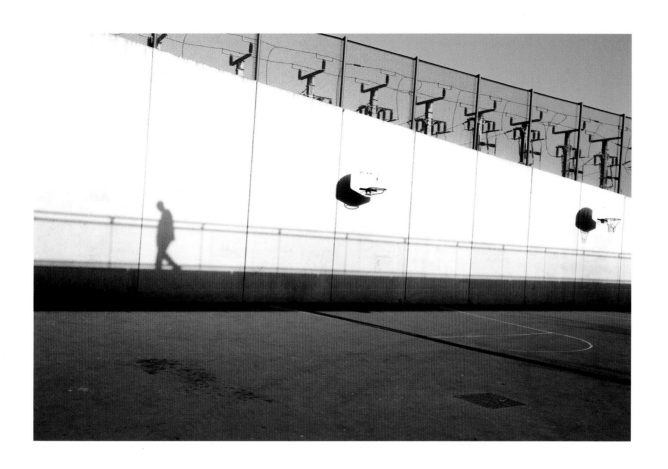

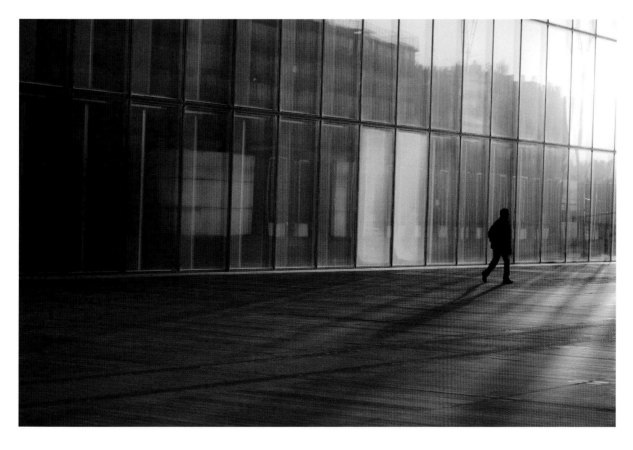

left. Passing
above top. Shadow on court
above bottom. Bibliothèque Nationale de France

View of Basilique du Sacré-Cœur up rue de Steinkerque

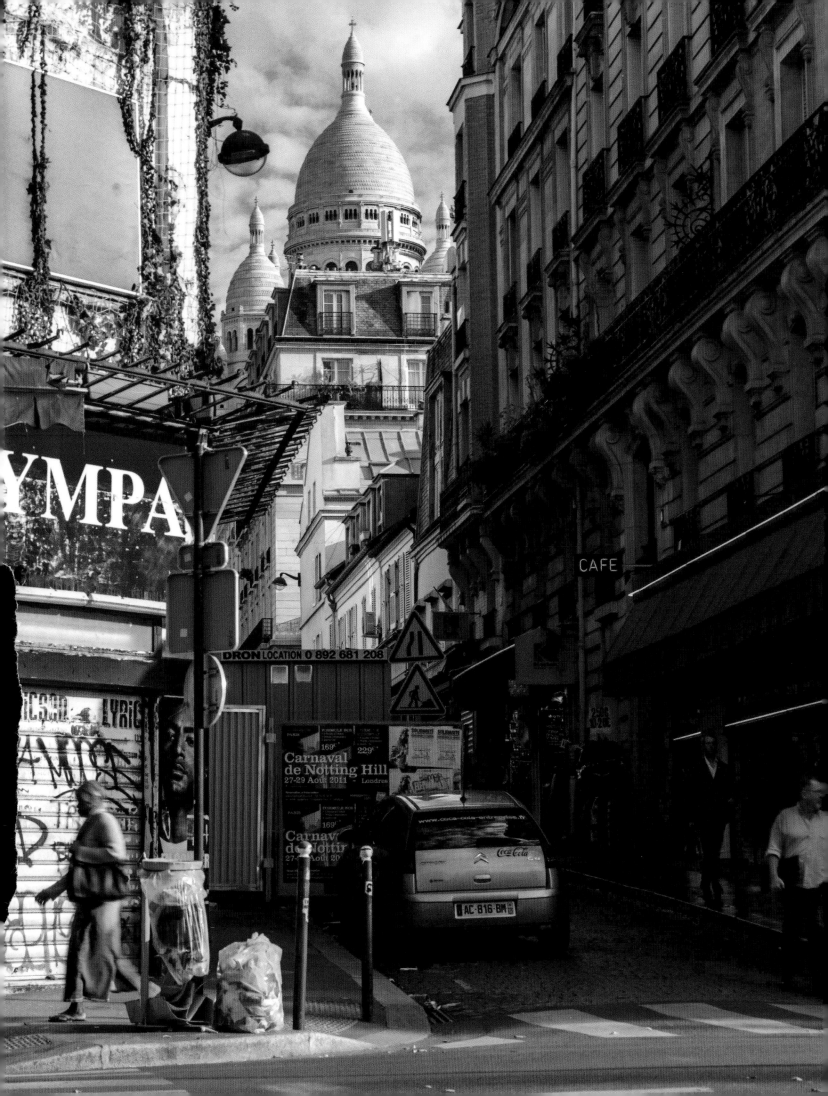

ABOUT ANTHONY EPES

Photo by: Theo Epes

Anthony Epes is a fine art and commercial photographer from California who has been based in London since 2000. *London at Dawn* was originally published in two editions in 2003/4 by Metro Publishing. The project was inspired by John Bird, founder of The Big Issue, who came up with the idea having slept rough in the streets of London in the 1960s. Anthony is currently travelling with his family and shooting other cities at dawn including Venice, Mexico City, Singapore, Istanbul and San Francisco. In 2013 he set up Cities at Dawn Publishing to publish *Paris at Dawn* and the updated edition of *London at Dawn* as the first titles of this new series.

Anthony has exhibited widely in the UK, United States and Japan, and has run two galleries in London, The Fish House in Borough Market and The Concrete Basement in Waterloo, as well as numerous pop-up galleries, of which he is a keen proponent. He has a growing number of private collectors of his work. Anthony is a senior UK member of the International Environmental Photographers Association and a member of the Courvoisier Future 500, a collection of revolutionary spirits in their field. His ongoing work includes a project on The Homeless World Cup and The Belly Project.

In 2011 Anthony launched the Cities at Dawn Photography Workshops, currently in London, Paris and Venice. Anthony takes amateur photographers and intrepid city dwellers through the dawn and early morning streets to teach them professional photography skills on the move. Anthony is regularly invited to speak about his work at organisations such as The Southbank Centre, Coin Street, Create London festival and Foyles Bookshop.

www.anthonyepes.com

www.citiesatdawn.com

Acknowledgements

This project is the culmination of much dedication and hard work, not all my own. I would like to take this time to thank all of those involved. Our book designer Helen Crawford-White for the beautiful design; Paul Minett for his ever-ready help in getting the book prepared at lightning speed; Joël Brisse for providing his most incredible Parisian pad where my family and I spent many happy weeks; Louise Woodhouse for her assistance; James Lohan from Mr and Mrs Smith for encouraging us to take the leap and self-publish; Bill Samuel for connecting us to the world's greatest bookshop, Foyles; Mohara Gill and David Owen at Foyles for their fantastic advice and interest in the project; Alex Feytis for her invaluable help on the French captions.

I would like to thank my family, without whom I could not do what I do. Tessa Swithinbank for her tireless efforts in proofing the book, grandchild-wrangling and being an incredible support; John Bird for the idea for the project, his inspiration and great writing; Parveen Bird for her always upbeat help; Paddy Bird, Lou Bird and Sara Mason for their thoughtful advice and feedback and Kipp, Sonny and Ishy Bird for being most excellent.

Thank you to Diana, my wife, who inspires and helps me to do the things I do; my mother Mary; my sister Litha; my brother-in-law Barney and my wonderful nephews Aidan and Elias.